General Editor
David Piper

Vermeer
The Complete Paintings

Albert Blankert

Van Meegeren
Maurizio Villa

Translated by Lucia Wildt

GRANADA
London Toronto Sydney New York

Foreword by the General Editor

Several factors have made possible the phenomenal surge of interest in art in the twentieth century: notably the growth of museums, the increase of leisure, the speed and relative ease of modern travel, and not least the extraordinary expansion and refinement of techniques of reproduction of works of art, from the ubiquitous colour postcards, cheap popular books of colour plates, to film and television. A basic need – for the general art public, as for specialized students, academic libraries, the art trade – is for accessible, reliable, comprehensive accounts of the works of the individual great masters of painting; this has not been met since the demise before 1939 of the famous German series, *Klassiker der Kunst*; when such accounts do appear, in the shape of full *catalogues raisonnés*, they are vast in price as in size, and beyond the reach of most individual pockets and the capacity of most private bookshelves.

The aim of the present series is to provide an up-to-date equivalent of the *Klassiker* for the now enormously enlarged public interested in art. Each volume (or volumes, where the quantity of work to be reproduced cannot be contained in a single one) catalogues and illustrates chronologically the complete paintings of the artist concerned. The catalogues reflect as far as possible a consensus of current expert opinion about the status of each picture; in the nature of things, consensus has yet to be reached on many points, and no one professionally involved in the study of art-history would ever be so rash as to claim definitiveness. Within the bounds of human fallibility, however, every effort has been made to achieve both comprehensiveness and factual accuracy, while the quality of reproduction aimed at is the highest possible in this price range, and includes, of course, colour. Every effort has also been made to hold the price down to the lowest possible level, so that these volumes may stay within the reach not only of libraries, but of the individual student and lover of great painting, so that they may gradually accumulate their own 'Museum without Walls'. The introductions, written by acknowledged authorities, summarize the life and works of the artists, while the illustrations place in perspective the complete story of the development of each painter's genius through his career.

David Piper

Introduction

Vermeer is today the subject of great popular acclaim and many books have been written about his work. These have tended, however, to describe the special qualities of his extraordinary technique in imprecise, almost lyrical terms and what is lacking is an appraisal of his paintings in their historical context. When this is undertaken it becomes apparent that Vermeer's greatness is not as an innovator: he did not create a new style, nor did he introduce radical new ideas. On the contrary, both his style and his subject-matter follow closely those of other Dutch painters of his milieu. His great achievement lies instead in the recognition of new possibilities within the existing forms and in his ability to recast them in original ways. In his earliest works, the paintings of religious and mythological subjects known in the seventeenth century as 'history paintings', his approach was traditional. The genre derived from the Italian style but Vermeer was alone among contemporary Dutch artists in turning direct to Italian models. Once aware of his objectives, Vermeer rarely altered course, working on one problem at a time with intense and unrivalled concentration. The result is the portrayal of a perfect world in a manner so natural that it seems almost effortless.

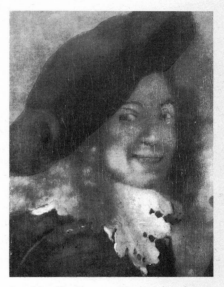

Detail from The Procuress *(No. 3). It has often been thought that this is a portrait of the young Vermeer. He wears the same fanciful dress as the painter in* The Art of Painting *(No. 19).*

His life

Johannes Vermeer was born in Delft in 1632, the son of Reynier Jansz, a poor silk-worker, who is later described as an innkeeper. His father was also involved in the art trade, an activity which may well have brought him prosperity for, by the time of his death in 1652, Reynier Jansz owned a large house, known as the *Mechelen*, of which part was an inn. It was situated on the Marktveld, the principal square of Delft. By birth Vermeer belonged to the class of small entrepreneurs, of which artists were a part, who formed the backbone of the Dutch Republic. He was accepted by the artists' guild in Delft at the end of December 1653, just a year after his father's death, the entry requirement being that he should have spent several years as an apprentice to a recognized master. It is probable that this master was Leonaert Bramer (*c.* 1595–1674), who was the leading painter in the town until the early 1650s.

*Vermeer's signature: (*above*) in the register of the Guild of St Luke at Delft (*below, from the left*) from paintings Nos. 3, 9, 22, 31*

Although pure supposition, this view is supported by one piece of evidence: intervention by Bramer on Vermeer's behalf when the latter wished to marry and the mother of the bride, a rich woman who considered that her daughter was marrying beneath herself, refused to give her consent. Bramer no doubt reassured her about Vermeer's artistic and, perhaps more important, financial promise. Vermeer's marriage to Catharina Bolnes took place in April 1653, some eight months before his acceptance into the painters' guild, and the young couple went to live in the *Mechelen*. Although living on the premises, there is no evidence that Vermeer succeeded his father as innkeeper of the *Mechelen*. He may, however, have leased the inn as a way of providing himself with a regular income in addition to that derived from his painting, to help support his large family, for Catharina gave birth to more than 14 children, of whom at least 11 survived.

There is good reason to suppose that Vermeer's production was small. Three of his paintings were recorded as belonging to his widow. Twenty-one were listed in the catalogue of an auction held in Amsterdam in 1696 and another five in other auction catalogues of the late seventeenth and early eighteenth centuries. Almost all these paintings can still be identified, and of the thirty or so which are now considered to be autograph works, almost all can be identified as those mentioned in early documents. It seems likely, therefore, that Vermeer's oeuvre was small and that it has been well preserved. His limited production is apparently due, at least in part, to his meticulous working method.

It is known that Vermeer's paintings fetched good prices. The French nobleman, Balthasar de Moncoys, who visited Delft briefly in 1663 wrote in his diary: 'In Delft I saw the painter Vermeer who did not have any of his own works: but we did see one at a bakers for which six hundred livres had been paid, although it contains only one figure for which six pistoles would have been too high a price in my opinion.' The baker, a more appreciative connoisseur than the French aristocrat, was probably Hendrick van Buyten, a master baker who, shortly after Vermeer's death, accepted two of his paintings from Catharina Bolnes as a guarantee for an unpaid bill of 617 guilders.

There was no clear differentiation in the seventeenth century between the professions of artist and art dealer, and Vermeer augmented his income by buying and selling paintings by other artists. Despite this, he always signed himself 'painter' on official documents. Painters were often consulted to appraise the value of works of art for the purposes of taxation or in cases of inheritance, and Vermeer was called in on at least one occasion to give his opinion about some paintings whose authorship was in dispute.

Vermeer's financial position was reasonably secure until the great economic crisis of 1672, which was brought about by Louis XIV's invasion of the Netherlands. Vermeer was forced to let his large house and move his entire family to the house of his mother-in-

law, and it is possible that the financial setbacks of these years hastened Vermeer's early death. He was buried in Oude Kerk at Delft on 15 December 1675 'leaving behind 8 minors'.

After his death Vermeer's widow did all she could to retain some of his paintings but the large debts which the painter left behind him forced her to sell them all. *The Art of Painting* (No. 19) she sold to her own mother 'in partial settlement of her debt'. However, such attempts to extricate herself from a desperate financial position were unsuccessful. On 30 April 1676 the Supreme Court of Holland declared Catharina bankrupt.

During Vermeer's lifetime an important patron had been the printer Jacob Dissius, a neighbour of his on the Marktveld. An inventory of his possessions, drawn up in 1682, included no less than nineteen paintings by Vermeer. He must later have added two more works by the artist to his collection for it is almost certain that the twenty-one Vermeers auctioned in Amsterdam in 1696 were those which had belonged to Dissius.

His work
Despite the fact that only three of his paintings are dated (*The Procuress* 1656, *The Astronomer* 1668 and *The Geographer* 1669, Nos. 3, 23 and 24), it is possible to trace Vermeer's artistic development since his oeuvre has been preserved almost in its entirety.

Vermeer began his career as a history painter. The two compositionally similar canvases, *Christ in the House of Martha and Mary* (No. 1) and the *Diana and her Companions* (No. 2) must be dated before *The Procuress*, that is after Vermeer joined the guild in December 1653 and before 1656. Despite their achievements in landscape painting, still-life and interiors, seventeenth-century Dutch painters continued to pay tribute to the idea, imported from Italy, that the most noble form of art was history painting. In Haarlem history painting flourished for over fifty years in the works of the so-called 'Academists', and if these paintings have not in recent years received the attention they deserve from art historians, it must be principally because of a prejudice against the subject-matter rather than any deficiency in the artists. Rembrandt devoted himself largely to history painting, as did most of his pupils, including Ferdinand Bol, Gerbrand van der Eeckhout and Aert de Gelder. Many ambitious and talented young painters, who eventually became specialists in one or another non-history genre, began their careers, as Vermeer did, as history painters.

Vermeer's *Christ in the House of Martha and Mary* shows a strong affinity with *Christ and the Adulteress*, 1653 (see page 6), the most important youthful work of Gabriel Metsu of Leiden, who later specialized in genre scenes. This is borne out by its robust style, rather ponderous draped figures and bright colours set against a dark background.

Vermeer seems also to have been particularly interested in the work of Jacob van Loo. The figures in *Diana and her Companions* closely resemble those in the background of van Loo's painting of the same subject (now in the Bode Museum, East Berlin). Similarly, in *Christ in the House of Martha and Mary*, Vermeer adopts van Loo's lively arrangement of linear highlights which suggests the play of light over folds of fabric.

The composition of this latter painting follows so closely that of *Christ in the House of Martha and Mary* by Erasmus Quellinus (Valenciennes, Musée des Beaux Arts), that Vermeer must have been familiar with this Flemish painter's work. Quellinus, who had been a pupil of Rubens in Antwerp, was commissioned shortly after 1650 to help decorate the walls of Amsterdam's new Town Hall, now the Royal Palace. The city council asked various painters to produce large-scale scenes from the Old Testament and from Roman and Batavian history, thus giving an added stimulus to history painting in Holland in the 1650s.

In technique Vermeer's early painting is profoundly Italianate, the artist having taken his lead from the Italian paintings he had studied. Although many Dutch painters visited Italy there is no reason to believe that Vermeer did the same, for there was a flourishing trade in Italian paintings in Holland and he would have had every opportunity of studying them in his own country. He may also have gained much of his knowledge from Leonaert Bramer, who is known to have spent ten years in Italy.

5

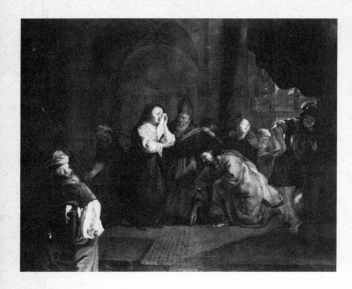

Gabriel Metsu, Christ and the Adulteress *(135 × 164/s.d. 1653/ Paris, Louvre)*

Samuel van Hoogstraeten, Perspective Box (London, National Gallery). One wall has been removed in this reproduction. The correct perspective effect is achieved instead if the spectator looks straight at the opposite practical opening in one of the walls

Cornelis Gijsbrechts, Trompe-l'oeil *depicting the back of a painting (66 × 86.5/Copenhagen, Statens Museum for Kunst)*

The Delft of Vermeer's youth was artistically provincial, a situation that was changed dramatically around 1650 by an influx of talented young artists. The landscapist Adam Pijnacker and the still-life painter Willem van Aelst were among them, but more significant for Vermeer's development was Carel Fabritius (1622–54). Fabritius, who had begun his career as a history painter in the style of his master Rembrandt, came to live in Delft in about 1650. He was in the master's studio in the early 1640s at about the same time as Samuel van Hoogstraeten, who writes about his fellow apprentice in his *Inleiding tot de Hooge Schoole des Schilderkonst* ('Introduction to the High School of Painting') which was published in Rotterdam in 1678. Van Hoogstraeten stresses Fabritius' interest in problems of perspective and illusion, something which is borne out in the vivid illusion of reality created in several of his paintings, notably the amazingly lifelike *Goldfinch* of 1654 (Mauritshuis, The Hague). It was painted in the year of Fabritius' death in the explosion of the municipal powder magazine at Delft, and in that same year Samuel van Hoogstraeten, who had returned from Amsterdam to his native Dordrecht, created the first known *trompe l'oeil* painting.

The works of Fabritius and van Hoogstraeten, which were later to influence Vermeer dramatically, were at first ignored by him. The background of *The Procuress* (No. 3) of 1656 is represented in the traditional manner as a flat plane rather than as a convincing interior space. In his subject-matter he was undoubtedly influenced by an already old-fashioned painting by Dirck van Baburen, a follower of Caravaggio from the Utrecht school, which he had in his possession. This was *The Procuress*, 1622 (page 8), which hangs today in the Museum of Fine Arts in Boston. He would also have been aware of the work of Gerard Ter Borch and other genre painters who were at that time producing paintings of high quality which more often than not contained erotic allusions.

It was not until the *Girl Asleep at a Table* (No. 4), painted soon after *The Procuress*, that Vermeer finally settled on the depiction of a figure or figures in contemporary dress in a contemporary interior, which was to remain his principal theme. The initiative to change his artistic direction so radically was probably due to the influence of Pieter de Hooch, his senior by three years, who had settled in Delft around 1653 after training in Haarlem under Nicolaes Berchem. De Hooch's earliest dated

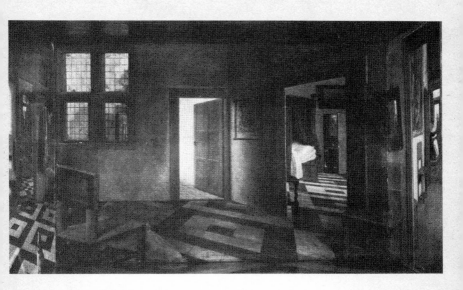

works are of 1658, and they show his style already fully developed. De Hooch poses his figures in the middle of large brightly-lit rooms. Not only are they placed prominently and convincingly within the picture space, but the lines of the ceiling beams, tiled floors and window frames conform exactly to the laws of linear perspective, and the minute gradations of light reflected from walls and objects are recorded with the special sensitivity and precision which we associate with the work of the Delft painters. De Hooch can be said to have achieved a synthesis of the work of Ter Borch and of Fabritius and, building on the experiments of Fabritius, he also brought the

painting of the exterior world of sunlit houses, streets and courtyards to a hitherto unknown perfection.

Vermeer began by adopting de Hooch's method of simplifying composition. In the years 1658–61 he painted three canvases depicting either one or two half-length figures in the same corner of the same room, with the same window: *Officer with a Laughing Girl* (No. 5), *Girl reading a Letter at an Open Window* (No. 6) and *The Milkmaid* (No. 7). Only later did he compete with and surpass de Hooch on his own ground in *The Glass of Wine* (No. 8) in which two full-length figures are shown at a table in a spacious room. In all these paintings Vermeer recognized the potential in depicting bright, unfiltered sunlight falling through a window, something which had not been thought advisable during the seventeenth century when handbooks directed painters to work in studios with north light or, if they could not avoid direct sunlight, to line their windows with oilpaper. It seems likely that Vermeer achieved his results by working as much as possible from nature rather than following the common practice of making a number of preliminary sketches and then rearranging the elements on the canvas. One example of his faithfulness to

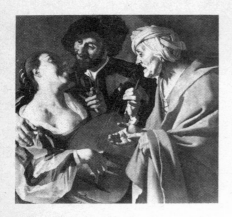

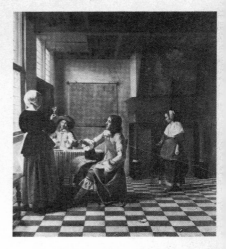

(above) *Dirck van Baburen*, The Procuress
(101 × 107)/s.d. 1622/ Boston, Museum of Fine Arts)

nature is his representation of maps and globes, which are depicted with such great accuracy that nearly all of them can be precisely identified.

In order to achieve his technical mastery, Vermeer limited his subjects in the years from 1658 onwards to a few objects in a small corner of one particular room. The theory that he used a camera obscura, which would throw the image directly onto the canvas, is very plausible. He refined his technique in such a way that perspectival space and depth become crystal clear and the different textures of polished wood, thick carpet and shining silk seem almost tangible.

Vermeer observed that areas of sunlight surrounded by shadow are transformed by the eye into patches and spots of pure light, and he was able to reproduce this effect. He achieved it through a *pointille* technique, which can be seen quite clearly in the brightly lit areas of the paintings from the years 1658–61. In *The Milkmaid*, for example, Vermeer dwells lovingly on the fabrics, crockery and metal, the structure of the plaster wall, and the light that plays over them all. The effect is one of spontaneous naturalism, but he avoids any disjunction of forms or disorder of colour by means of a calculated organization of light and shadow, of large and small forms, and of curved and straight lines. A diagonal line running from

upper left to lower right would separate a predominantly illuminated area from one predominantly cast in shadow. Only the flat, neutral wall in the background is evenly lit. The patches of light between the empty wall surface and the busy foreground are connected by the massive vertical of the milkmaid herself. The eye-catching still-life on the table, which defines the foreground area, also catches the light, but it is snugly anchored by the area of shadow around it.

The two exterior views, *The Little Street* (No. 9), and *The View of Delft* (No. 10) also belong stylistically to the group of works dating from 1658–61. The former owes much to de Hooch's courtyard scenes. The depiction of sunlight in *The View of Delft* has resulted in the painting being compared with the work of the French Impressionists, but this exact and precise cityscape could equally well be compared with the painstakingly exact *vedute* painted by the late seventeenth-century Dutch and eighteenth-century Italian artists. It shows the Schiekade in Delft, between the Rotterdam and Schiedam gates, viewed from across the River Schie. The very house from which Vermeer worked can be identified. Once again he seems to have painted from nature with the help of a camera obscura.

All the paintings in this group from the years 1658–61 display the same solid, emphatic modelling. The paint is applied thickly,

particularly in the light areas, and various small areas of almost lumpy paint give the whole canvas an uneven texture. In the *Woman weighing Gold* (No. 15) this firm modelling has been discarded in favour of a softer, quieter rendering of the textures, a dimming of the light and a more subtle treatment of the details. Although the delicacy of this new phase has an affinity with the work of Gerard Ter Borch, a more direct influence on Vermeer in this respect was Frans van Mieris the Elder (1635–81), the most gifted pupil of the Leiden *Feinmaler* (literally, fine or precise painter), Gerrit Dou. Prodigiously talented and enormously successful during his lifetime, van Mieris, though younger than Vermeer, was an important influence on him in the years after 1660. Vermeer's groups of figures and even details of clothes are reminiscent of van Mieris and, most important of all, it was van Mieris' distinctive style, with its glossy, velvet-soft modelling and its vividly sculptural apprehension of form, that Vermeer studied with such care. Time and time again van Mieris and Vermeer painted the same themes in a similar manner, which certainly points to a close contact between the two, despite the fact that van Mieris was working in Leiden (compare No. 19 with page 10, No. 16 with page 9).

The *Woman weighing Gold* (No. 15), the *Woman with a Pearl Necklace* (No. 13) and the *Woman in Blue* (No. 14), all from the years 1662–5, show Vermeer examining the various possibilities presented by one particular idea. In all three paintings a table, casually covered with a cloth on which a few objects lie, forms the horizontal contrast to the vertical form of a woman shown almost in full-length. Within this simple compositional skeleton, the modelling and delineation of the forms is almost unbelievably delicate. The problem of depicting large figures in a well-lit interior as naturalistically as possible was complicated by the apparent need to represent them engaged in some kind of activity. Vermeer, however, hampered by his extremely detailed technique, was unable to suggest movement of any kind in a realistic manner, and the gestures and the facial expressions of the couple in the *Officer with a Laughing Girl* (No. 5), for example, seem frozen. That other painters had this difficulty can be seen when

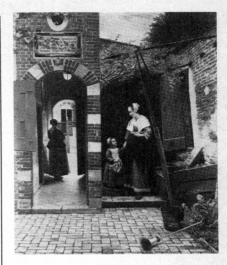

(opposite page) *Pieter de Hooch*, An Interior with a Woman drinking with Two Men *(74 × 65/ initialled/c. 1658/London, National Gallery)*

(above) *Pieter de Hooch*, Courtyard of a house in Delft *(73 × 60/s.d. 1658/London, National Gallery)*

(below) *Frans van Mieris*, The Duet *(32 × 25/s.d. 1658/Schwerin, Staatliches Museum)*

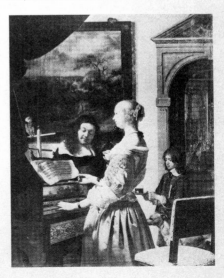

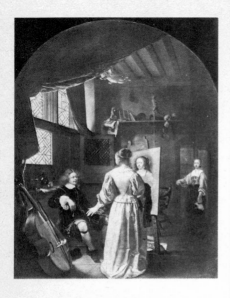

Frans van Mieris, The Painter's Studio *(60 × 46/s./ formerly at Dresden, lost during World War II)*

we look at de Hooch's interiors of 1658, in which the figures seem similarly static. Painters of genuine *trompe-l'oeil* scenes, however, found a way around this dilemma by depicting only still-life objects. Vermeer's solution in his later work was to engage his figures in pursuits in which they could quite legitimately remain motionless, thus creating a *trompe-l'oeil* effect while still including figures in the compositions. So, in the *Woman weighing Gold*, he portrays his subject at the very moment when she is concentrating on the scales as they come into balance, and her eyes, which we should expect to reveal life and movement, are hidden behind her downcast eyelids. Vermeer's contemporaries would undoubtedly have been quick to recognize the connection between the action of the woman and the painting on the wall behind her, which depicts the Last Judgement, the day on which all souls will be weighed in the balance. The mirror is a frequently employed symbol of vanity while the gold and the pearls on the table represent the transience of earthly wealth which will have no value on the Day of Judgement: only the alloy of the soul will have

weight. With characteristic subtlety, Vermeer hides the representation of St Michael weighing souls behind the woman's head.

The Music Lesson (No. 16) is to be dated soon after the three paintings of single women, for in it Vermeer develops his newly-adopted compositional devices into a more complex structural design. He shows the girl playing the clavecin from behind, so that her hands are not visible. Her face is seen reflected in the mirror. Any possibility of movement is in this way avoided, and echoed by the almost statuesque figure of the listening man. A lively, forceful rhythm guides our glance over the opulently covered table in the foreground, the upright chair, and the *viol da gamba* lying on the floor. It does not dissipate when our glance reaches the rectangular back wall, for the rhythm is picked up by a series of clearly indicated rectangular forms set against the wall and parallel to it—a mirror, a painting, and the clavecin. The carefully calculated movement into depth, and the carefully placed rectangles in the background all contribute to a single impression—that of a commodious, box-like space which scrupulously obeys the laws of perspective.

In *The Concert* (No. 17), Vermeer presents a more circumscribed view of a similar subject and omits the ceiling and the side walls of the room. Now it is the man who is seen from the back: a woman singing is seen in three-quarters view, and the woman at the harpsichord is viewed in profile. This time her hands are clearly visible. Whether *The Concert* predates the *Music Lesson*, with which it has so much in common, or is a later version of it, is not altogether certain.

In his allegory, *The Art of Painting* c. 1662–8 (No. 19), Vermeer represents a moment of inaction while retaining a sense of vitality – an effect which he realized here even more ingeniously than in any of his other works. The girl who poses is naturally quite motionless. However, we might expect some movement from the painter's right hand, which is engaged in painting the laurel wreath. But Vermeer arrests the moment, depicting the motionless instant when the painter has turned his head to the left to study his model and consider how to place his next brush-stroke. No other work by Vermeer so flaw-lessly integrates naturalistic technique,

brightly illuminated space and a completely ordered composition. Superbly worked-out details can be enjoyed individually and yet are perfectly integrated into the larger sunlit space. It seems likely that Vermeer spent a number of years working on this painting and that the subject was suggested to him by numerous allegorical representations of Painting decorating the new building of the Delft guild of painters. The building was begun in 1661 on the *Voldersgracht*, directly behind Vermeer's house, and Vermeer served as an officer of the guild in 1662–3 while it was being constructed.

In the nineteenth century, when Vermeer had just been rediscovered, *The Art of Painting* was considered to be a realistic glimpse into a painter's studio. Theophile Thoré even speculated that it showed Vermeer's self-portrait. Today, however, its allegorical intention is recognized. Many of its details can be clarified by comparison with the *Iconologia*, written by the influential Italian emblem deviser Cesare Ripa, and published in a Dutch edition in 1644. Since painting is an art of imitation, the mask on the table is an appropriate symbol for it. Ripa wrote that 'the mask and the ape show the imitation of human activities'. The costume of the painter is not contemporary but is inspired by the clothing depicted in later medieval art, and to a seventeenth-century viewer the painter would have been dressed in an antique manner. The woman who poses for him wears a laurel wreath and carries a book and a trumpet, attributes, as mentioned by Ripa, of Clio, the Muse of History. Vermeer has expressed in a symbolic guise the idea that history painting was the artist's highest calling.

It is difficult to imagine a more successful realization of Vermeer's artistic ideals than *The Art of Painting*. After such perfection in the illusionistic depiction of reality there was little room for improvement and the other alternative, repetition, could only lead to sterility. Vermeer now faced a situation which other Dutch painters, consciously or unconsciously, faced at this time. Between the years 1650–70 the detailed description of 'reality' had reached a virtually unsurpassable level of perfection in the works of Vermeer, Frans van Mieris, Jan van der Capelle, Willem Kalf,

Adriaen van de Velde, Jacob van Ruisdael and others of their generation. This lack of room for further development of a younger generation of painters is perhaps the chief cause of the gradual decline of Dutch painting after 1670, for which so many differing reasons have been suggested.

The younger artists reacted in various ways to this crisis. Some created works dominated by a sense of restlessness or tension, others produced overcrowded compositions. Vermeer, by contrast, schematized and stylized his compositions. His new style, which began around 1667, can be seen in *Lady standing at a Virginal* (No. 25), where the composition is denuded of all superfluous details. All detail such as can be seen in *The Art of Painting* is removed – the uneven texture of the wall, the thick carpets and still-life objects. Light and shade are more rigorously bounded and more distinctly separated from one another than before. All the nuances and gentle transitions of shading are eliminated and instead of gradual transitions in the modelling, Vermeer now juxtaposes clearly defined and unmodulated tones of light and dark. He adopts a more sober and

Willem van Mieris, Woman at the Fishmonger's *(49 × 41/s.d. 1713/London, National Gallery)*

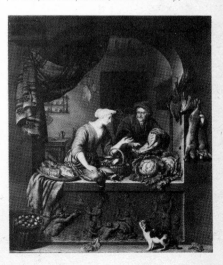

economical use of line, with an emphasis on the straight and the vertical, and the folds of the gown and the moulding of the window frame remind us of the fluting of Greek columns.

The Lacemaker (No. 26) also belongs to this late period. Seldom has human activity been recorded with such concentrated intensity. Vermeer achieved this by choosing a viewpoint from which the hands and the face of the girl are given the greatest emphasis and by eliminating every distracting detail.

Vermeer's late style finds its logical culmination in *The Guitar Player* (No. 28) where the details have become even more stylized than before. The figure is placed so far to the left of the picture that her right arm disappears off the edge while the right-hand side of the picture remains dramatically empty. As unprecedented for Vermeer as this unbalanced composition are the smiling face and lively pose of the model. Both the uncomfortable composition and the curious description of the figure endow the painting with a strange tension, and in some senses Vermeer seems wilfully to abandon the entire logical progression of his earlier work and accomplishment.

Vermeer's reputation
Vermeer is often cited as an example of a neglected genius. However, the fact that almost all his paintings have been preserved suggests that they were always highly valued works of art. During his lifetime they certainly brought high prices. On four different occasions Vermeer was elected to the ruling body of the painters' Guild of St Luke in Delft. Moreover, he is mentioned by Dirck van Bleyswijck in his *Description of the city of Delft*, published in 1667, in a short list of painters 'still alive today' and he is by far the youngest of those named.

Arnold Houbraken's *Groote Schouburgh der Nederlantsche Konstchilders* ('Great Theatre of Netherlandish Painters'), published in three volumes in the years 1718–21, was for many generations the chief source of information about the Dutch painters of the seventeenth century. Houbraken was poorly informed about developments in Delft and his treatment of Vermeer is worse than summary. The artist's name was forgotten but his works found their way (often under the names of others or in corrupted versions of Vermeer's name) into some of the best collections assembled during the eighteenth century. Between 1710–60 for example, four Vermeers – all attributed to other painters – were purchased by the Elector of Saxony, the Duke of Brunswick and the King of England. Historical accuracy may not have been the strong point of eighteenth-century collectors and connoisseurs; their taste, however, was superb.

At the end of the eighteenth century there are isolated mentions of paintings by Vermeer by Sir Joshua Reynolds, J. B. F. Lebrun and the Dutch merchant and engraver Christian Josi. In May 1822 the newly-opened Mauritshuis in The Hague bought the *View of Delft* for the then very substantial sum of 2,900 guilders. However, it was not until the French critic Theophile Thoré fell in love with the *View of Delft*, that serious research was undertaken into Vermeer's work. Thoré (1807–69) was a radical political writer as well as an art critic and he was forced to leave France after the collapse of the revolution of 1848. He went into exile in the Low Countries and there had the opportunity to undertake intensive historical research. He was the first to search out all the documents concerning Vermeer, to collect and analyse them. He published the fruits of his research in a series of articles in the *Gazette des Beaux-Arts* in 1866, an enthusiastic study which was to bring Vermeer a wide international reputation for the first time. Although modern research has trimmed Thoré's list of Vermeer's paintings, he provided a solid basis for the reconstruction of the small group of sublime paintings that are today accepted as the authentic works of Vermeer.

Christ in the House of Martha and Mary (No. 1; detail)
Vermeer, the supreme genre painter, began his career as a painter of large-scale history pictures. The composition of this one, painted around 1654–6, is based on a contemporary painting of the same subject by the Flemish painter Erasmus Quellinus, who was working in Amsterdam.

Catalogue of the Paintings

All measurements are in centimetres, height first.
s.d. = signed and dated.

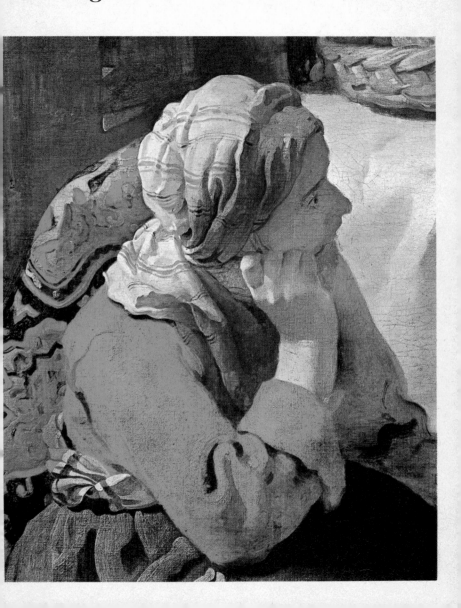

1 Christ in the House of Martha and Mary
Oil on canvas/160 × 142/s.
Edinburgh, National Gallery
of Scotland

(opposite) **Christ in the House of Martha and Mary (detail)**
The technique used by Vermeer in this early painting – the broad strokes of a loaded brush and the rich colours – display his careful study of Italian painting. Most probably he did not visit Italy, but had every opportunity to see Italian pictures in Amsterdam, where there was a flourishing trade in them.

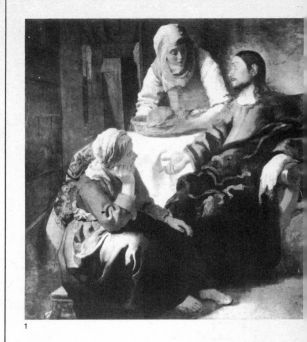

1

2

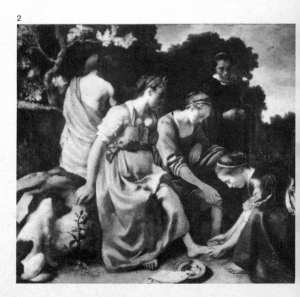

2 Diana and her Companions
Oil on canvas/98.5 × 105/
traces of signature
The Hague, Mauritshuis
In poor condition

Diana and her Companions (No. 2)
This painting is so unlike the majority of Vermeer's pictures that early cataloguers attributed it to Nicolaes Maes. There can, however, be no doubt of the attribution to Vermeer. His signature is still vaguely visible and is clearly by the same hand as the Christ in the House of Martha and Mary *and* The Procuress. *The composition is based on that of a painting by the Amsterdam history painter Jacob van Loo.*

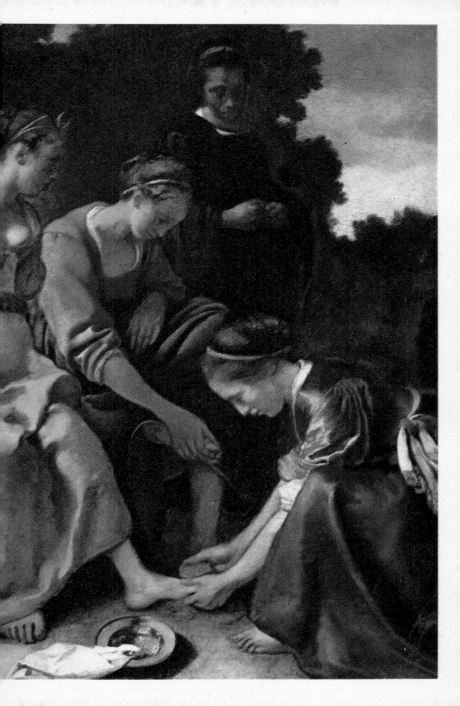

The Procuress (No. 3; detail)
This is the earliest of
Vermeer's paintings to bear a
date – 1656. The scale and the
technique are close to those of
the preceding two pictures but
in this case Vermeer has taken
his composition and subject-
matter from a follower of
Caravaggio working in
Utrecht.

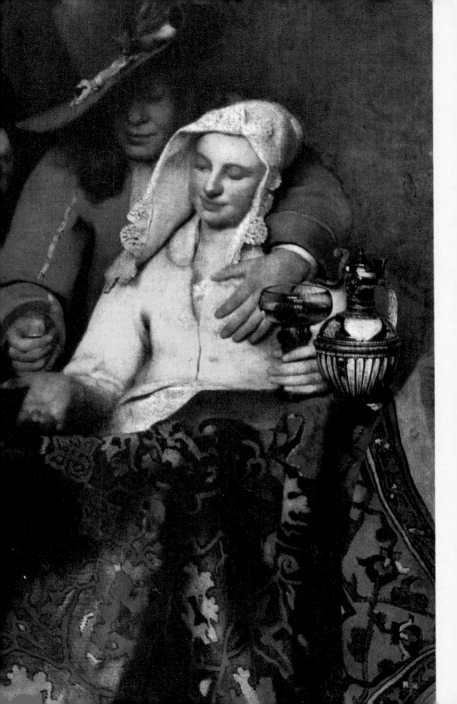

3 The Procuress
Oil on canvas/143 × 130/
s.d. 1656
Dresden, Gemäldegalerie

(*opposite; detail*)

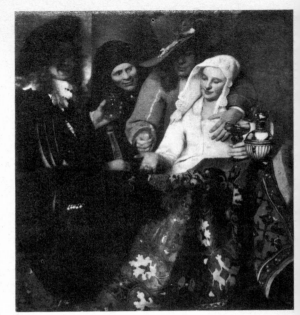

3

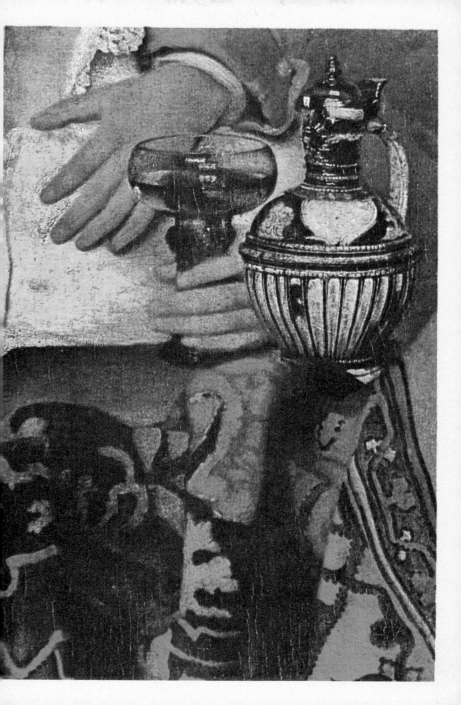

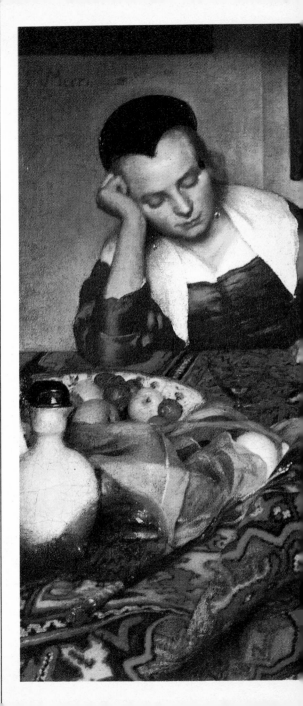

Girl Asleep at a Table (*No. 4;*
detail)
*In the catalogue of the auction
held in Amsterdam in 1696
which included 21 paintings by
Vermeer, this picture was
described as: 'A drunken girl,
sleeping at a table.' Such a
description has a moral sense:
drunkenness was undesirable,
and – by contrast –
temperance and moderation
were virtues to be striven for.*

4 Girl Asleep at a Table
Oil on canvas/86.5 × 76/s.
New York, Metropolitan
Museum
An X-ray photograph (No.
4a) shows that in the first
draft there was the shape of a
dog in the doorway

(opposite: detail)
*The view from the front room
through into another, known in
Dutch as a doorkijkje, displays
Vermeer's fascination with the
problems of representing
complex interior spaces. His
contemporaries, Nicolaes
Maes and Carel Fabritius,
were tackling similar problems
in the 1650s.*

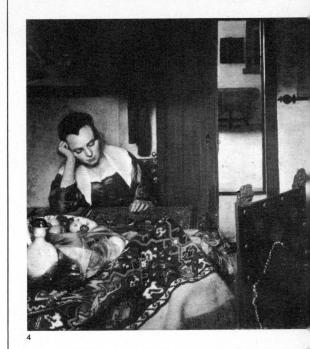

4

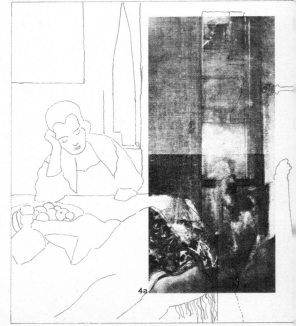

4a

**(over page) Officer with a
Laughing Girl** *(detail)*

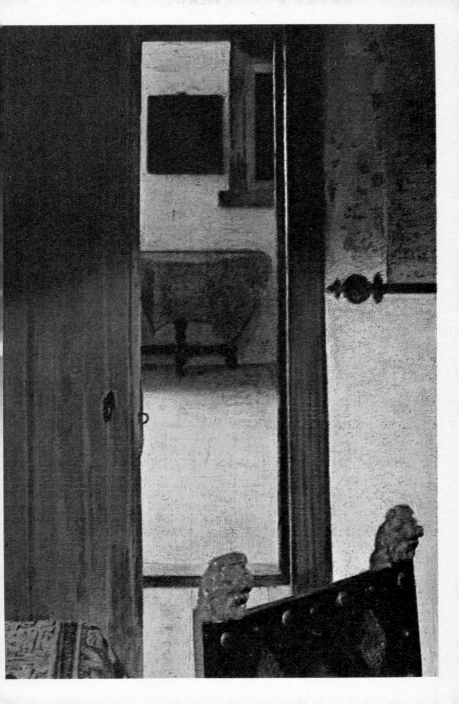

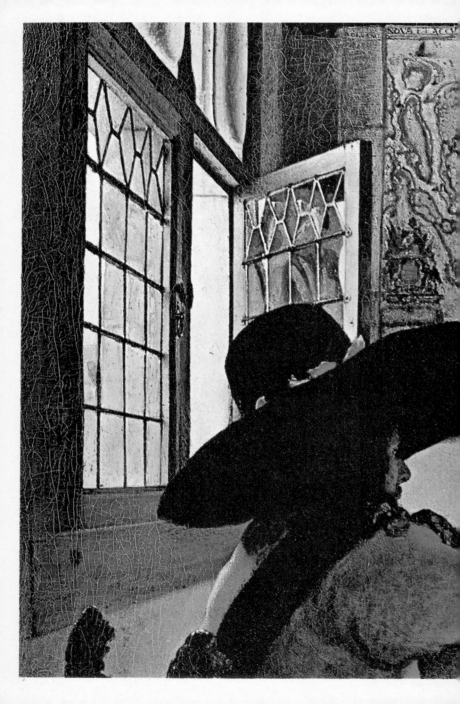

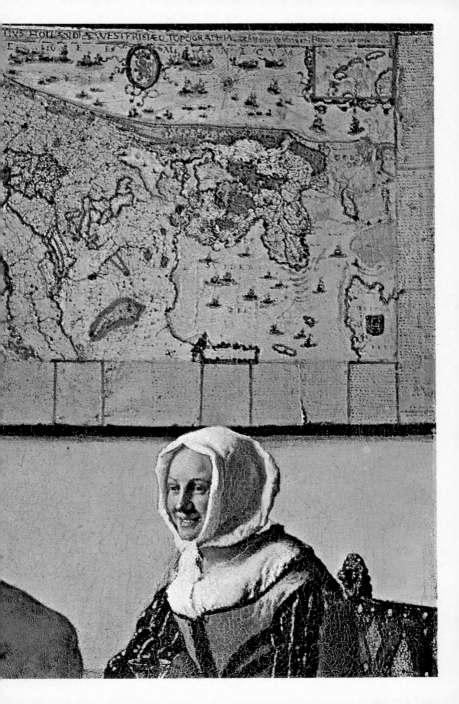

5 Officer with a Laughing Girl
Oil on canvas/50.5 × 46
New York, Frick Collection

(opposite: detail)
*Such is Vermeer's remarkable
descriptive ability that it is
possible to identify almost all
of the many maps and globes
in his paintings. In this case he
has painstakingly represented
a wall-map of Holland made
by Balthasar van Berckenrode
in 1620 (West is at the top).*

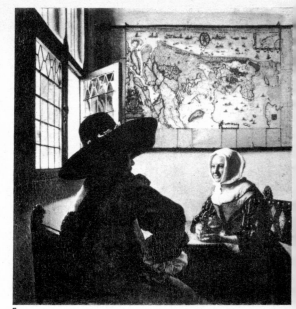

5

6 Girl reading a Letter at an Open Window
Oil on canvas/83 × 64.5/s.
Dresden, Gemäldegalerie

(opposite; detail)
Comparison with the previous colour plate will demonstrate the gradual simplification of Vermeer's compositions. Here a single figure is placed against a plain wall. Vermeer has begun to represent sunlight in the form of small dots of pure pigment, a technique which he went on to refine further.

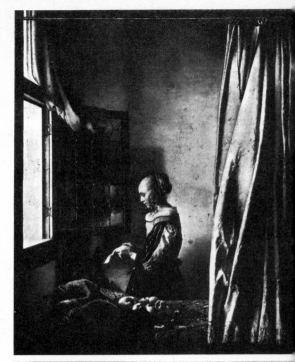

7 The Milkmaid
Oil on canvas/45.5 × 41
Amsterdam, Rijksmuseum

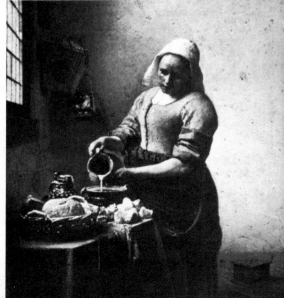

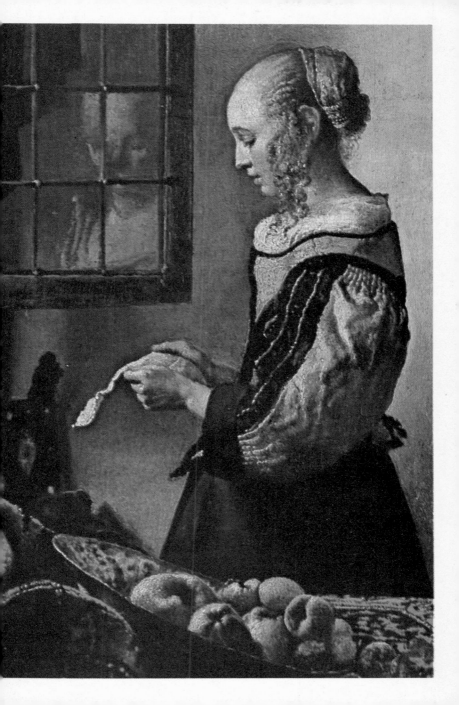

8 The Glass of Wine
Oil on canvas/65 × 77
Berlin, Gemäldegalerie

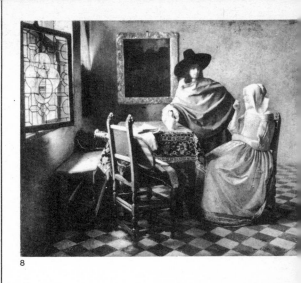

8

9

9 The Little Street
Oil on canvas/54.3 × 44/s.
Amsterdam, Rijksmuseum

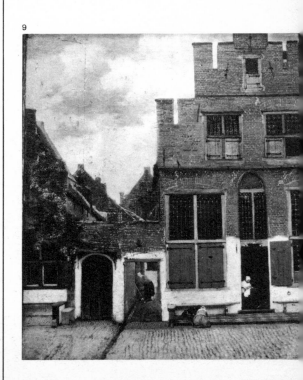

The Milkmaid (No. 7; detail)
Painted around 1660, this
belongs to the traditional
genre of kitchen interior,
which was originated in the
sixteenth century by the
Netherlandish painters Aertsen
and Beuckelaer. Vermeer's
immaculate technique raises
the subject far above anything
achieved by those painters.

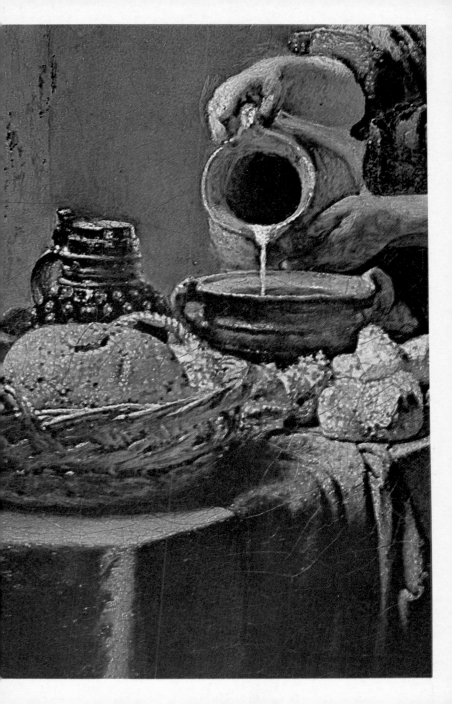

The Milkmaid (*No. 7; detail*)
*Vermeer's technique of
representing light with tiny
dots of pure pigment has been
called* pointilliste *and,
although different from Seurat's
famous style, the intention is
similar – the rendition of
texture by tiny areas of pure
colour.*

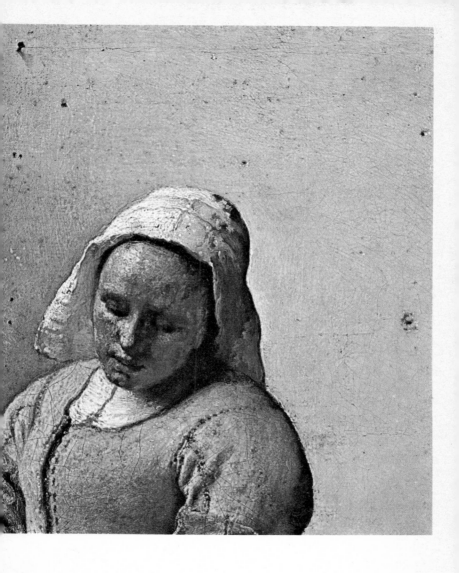

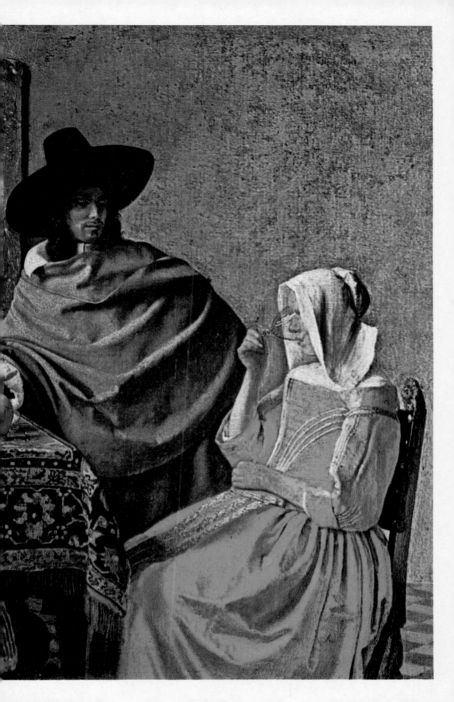

10 The View of Delft
Oil on canvas/98.5 × 117.5/s.
The Hague, Mauritshuis
At least four eighteenth-
century Dutch artists copied
this painting in the form of
drawings or watercolours;
one of the drawings (No.
10a, Frankfurt, Staedelsches
Kunstinstitut) was probably
the work of Reinier Vinkeles
(1741–1816)

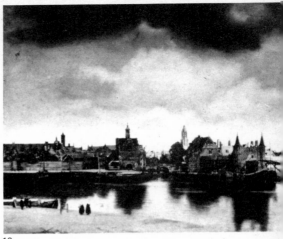

10

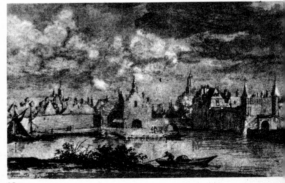

10a

**The Glass of Wine (No. 8;
detail)** (pp. 36–37)
*Here Vermeer follows Pieter
de Hooch in placing a man
and a woman in a spacious
interior. Yet despite this
ambitious composition, he did not
surrender any of the masterful
rendition of texture which he
had perfected. Polished wood,
porcelain, table, carpet, smooth
silk are all sharply
differentiated.*

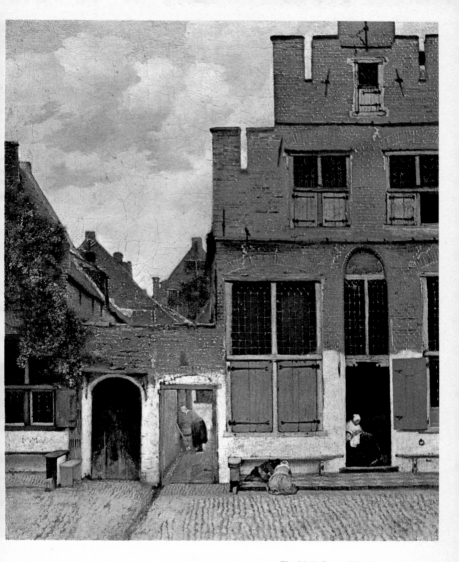

The Little Street (No. 9)
*Vermeer's contemporaries combined
reality freely with inventions of their
own. For instance, Jan van Goyen
painted a hilly landscape with a view of
the city of Leyden, a city which has flat
surroundings. Vermeer was an
exception: he followed nature much more
truthfully. In these houses he most
probably depicted an existing row of
houses in Delft.*

39

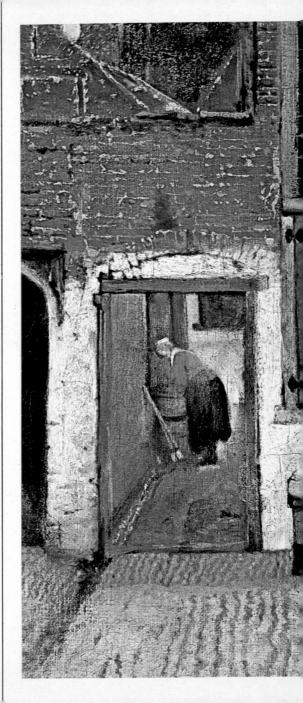

The Little Street (No. 9; detail)

(over page) *The View of Delft (No. 10)*
Purchased in 1822 for the newly-opened Mauritshuis, it was this painting which inspired the French critic, Theophile Thoré, to begin his rediscovery of Vermeer, which culminated in a long article published in 1866. It was this article which re-established Vermeer among the front rank of Dutch painters. The painting was also enthusiastically praised by Marcel Proust.

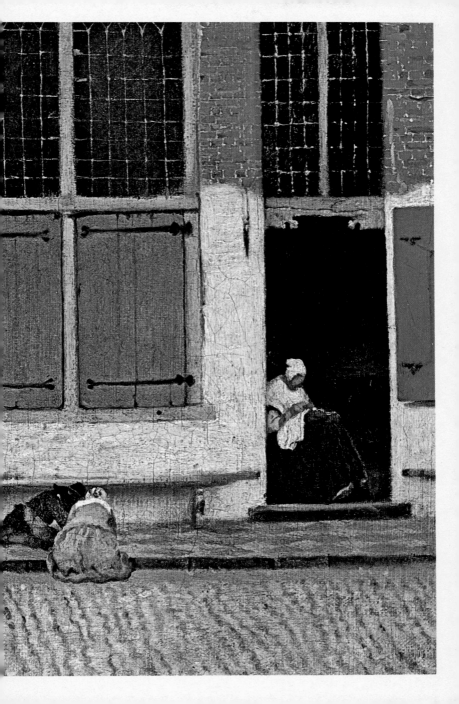

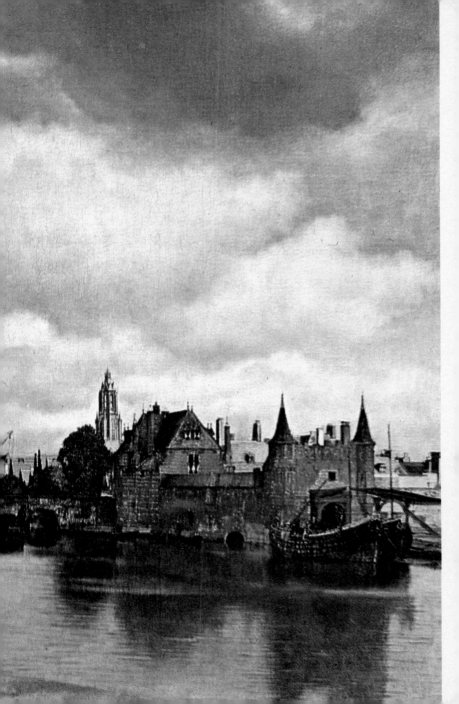

11 Woman and Two Men
Oil on canvas/78 × 67/s.
Braunschweig, Herzog Anton
Ulrich-Museum

(opposite; detail)
*Vermeer's more refined style
of the early 1660s can be seen
in this canvas. The
pronounced contrasts of form
of* The Glass of Wine, *for
example, are avoided in favour
of more delicate modelling of
forms.*

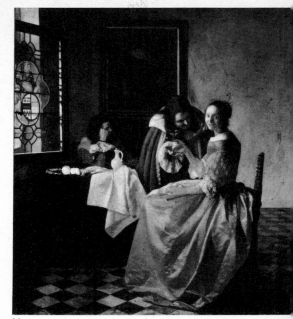

11

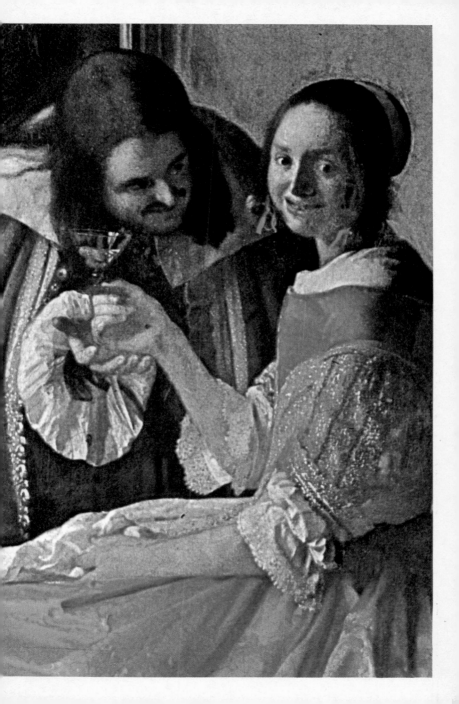

12 Woman with a Water Jug
Oil on canvas/45.7 × 42
New York, Metropolitan
Museum of Art
An X-ray photograph (12a)
shows how the original
drawing underwent slight
changes during the painting

(opposite; detail)
*This painting is a transitional
piece. Its brilliant lighting
recalls Vermeer's work of
1658–61, but its refinement of
technique places it a few years
later.*

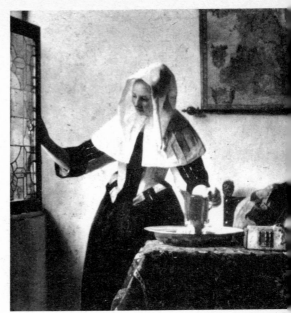

12

12a

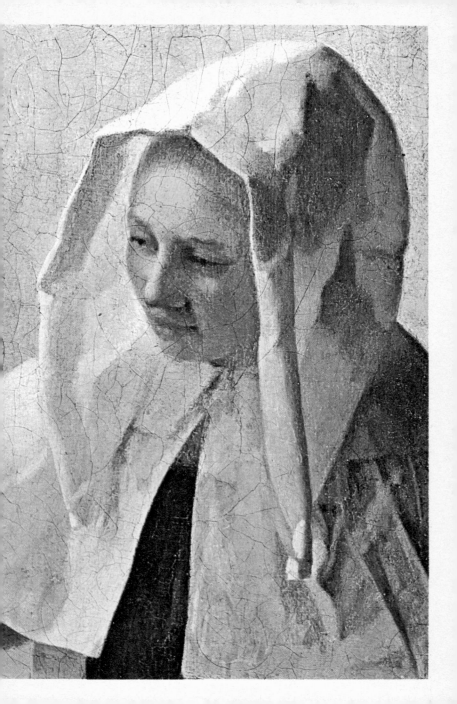

13 Woman with a Pearl Necklace
Oil on canvas/55 × 45/s.
Berlin, Gemäldegalerie

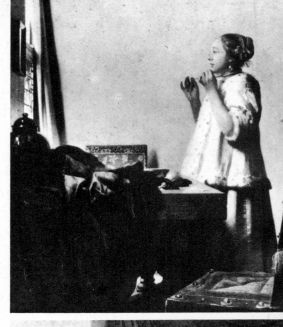

14 Woman in Blue reading a Letter
Oil on canvas/46.5 × 39
Amsterdam, Rijksmuseum

(opposite; detail)
*Here the blue ground suffuses
the whole surface. Because this
is Vermeer's only painting with
such a strong overall tonality,
it is likely that the blue is more
exaggerated now (as a result
of chemical change in the
pigment) than when the
picture was originally painted.*

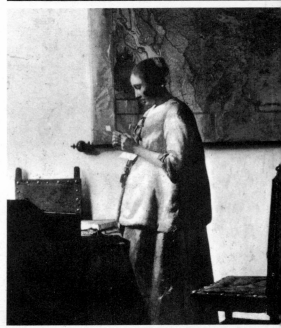

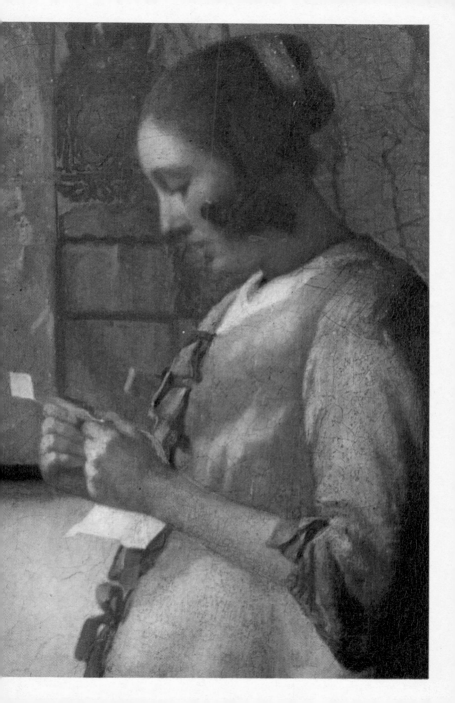

15 Woman weighing Gold
Oil on canvas/42 × 35.5
Washington, National
Gallery of Art

(opposite; detail)
*Vermeer's contemporaries
would have recognized the
connection between the action
of the woman and the painting
on the wall behind her,* The
Last Judgement, *the day on
which all souls will be weighed.
The gold and the strings of
pearls on the table represent
the transience of earthly
wealth.*

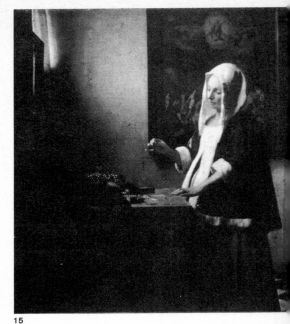

15

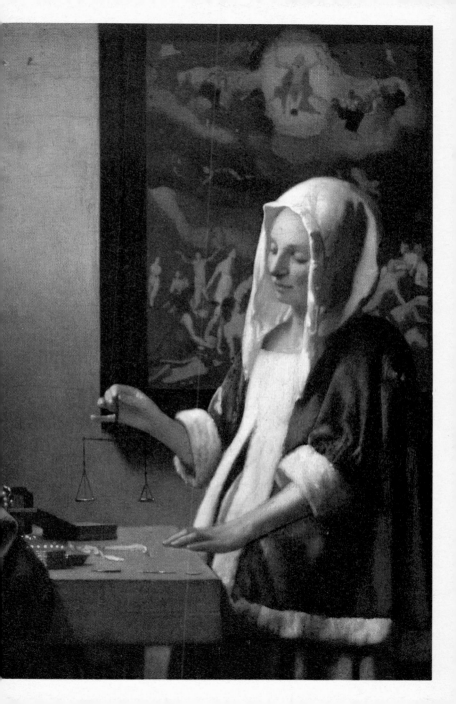

16 The Music Lesson
Oil on canvas/73.6 × 64.1/s.
London, Buckingham Palace

(opposite; detail)
Musica Laetitiae Comes
Medecina Dolor(um) *(Music,
Companion of Joy, Balm of
Sorrow)* is inscribed in
capitals on the cover of the
clavecin. It may also be taken
to express Vermeer's feelings
about painting.

16

17

17 The Concert
Oil on canvas/69 × 63
Boston, Isabella Stewart
Gardner Museum

**(over page) The Music Lesson
(detail)**
*In Vermeer's interiors his
figures are deliberately caught
in a moment of arrested
motion, about to perform a
particular action or just having
done it. They are also
sometimes figures shown from
the back, like this woman
playing the clavecin, whose
face can be glimpsed only in
the mirror.*

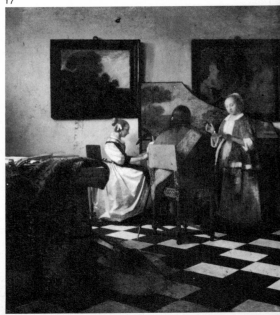

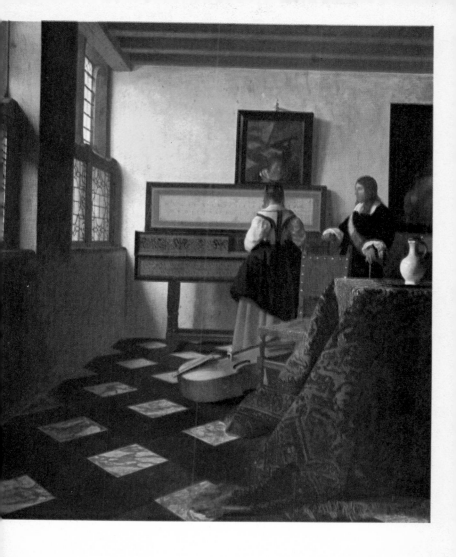

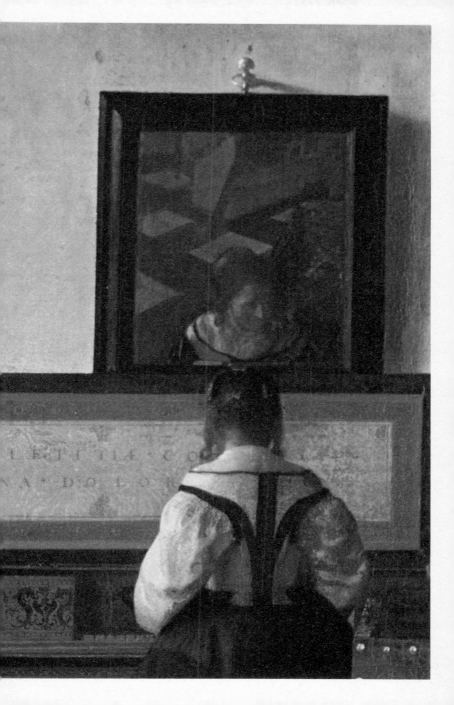

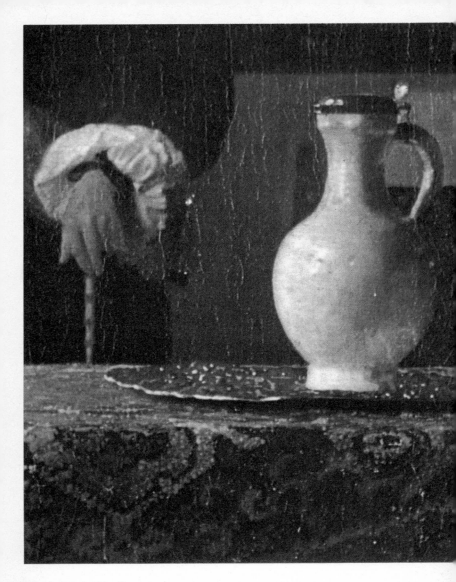

The Music Lesson (detail)
Vermeer's name, though not his works, was lost sight of during the eighteenth century. This picture was purchased in Venice about 1740 and later sold to King George III of England as a Frans van Mieris, an artist far better known at that time than Vermeer.

(opposite)
Vermeer has marked out the gradual recession with carefully spaced tiles of black and white, creating a light, open room which scrupulously obeys the laws of perspective.

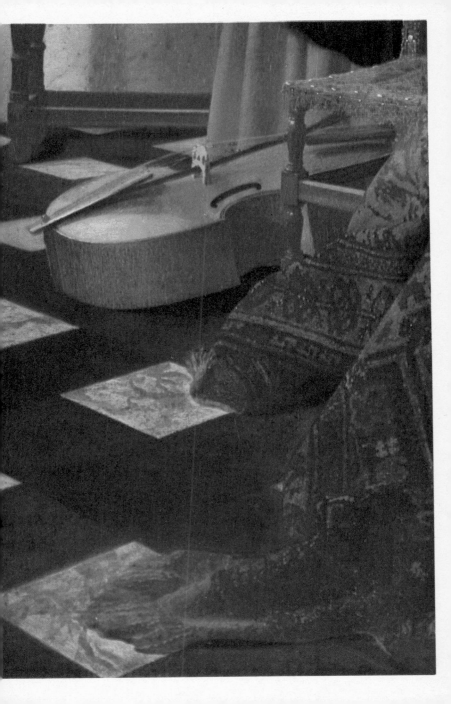

18 Girl with a Pearl Earring
Oil on canvas/46.5 × 40/s.
The Hague, Mauritshuis

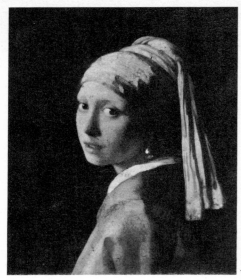

18

19

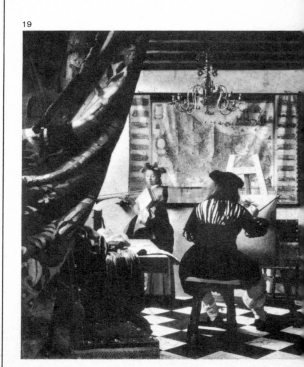

19 The Art of Painting
Oil on canvas/120 × 100/s.
Vienna, Kunsthistorisches
Museum

(*opposite*) *The Concert* (*detail*)
Unlike those of the woman in
The Music Lesson, *the hands*
of the woman playing the
harpsichord are clearly visible.
Yet once again Vermeer
allows her to evade our direct
glance. She is seen in profile,
while her accompanist has his
back to the spectator.

58

20 Lady writing a Letter
Oil on canvas/47 × 36.8/s.
Washington, National
Gallery of Art

20

(*opposite*) *Girl with a Pearl Earring (No. 18; detail)*
This unusual composition is difficult to place in the sequence of Vermeer's work. He concentrates on the glance the girl casts over her left shoulder as her eyes meet ours. Her shining eyes, moist lips and the modelling of her face and dress succeed in convincing us of their perfect naturalness.

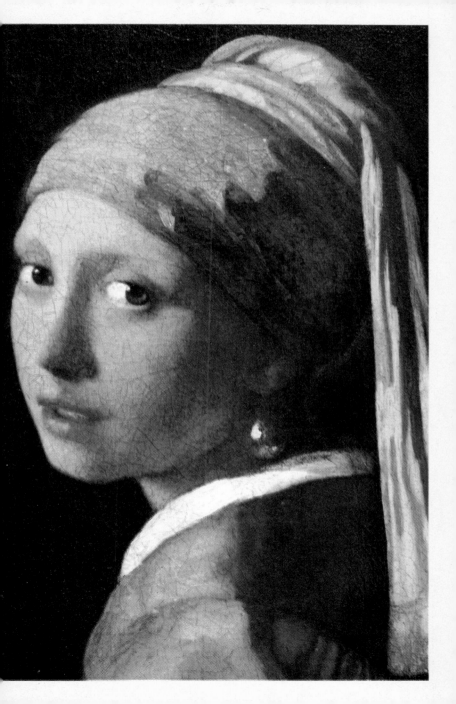

The Art of Painting (No. 19; detail)
Believed during the nineteenth century to show Vermeer at work in his own studio, this work is in fact an allegory concerning the art of painting. It was still in Vermeer's possession at the time of his death, and his widow did everything in her power to avoid selling it. The model has been posed as Clio, the Muse of History, wearing a laurel wreath and carrying a book and a trumpet. Thus the painter is shown depicting History, and History inspiring the painter.

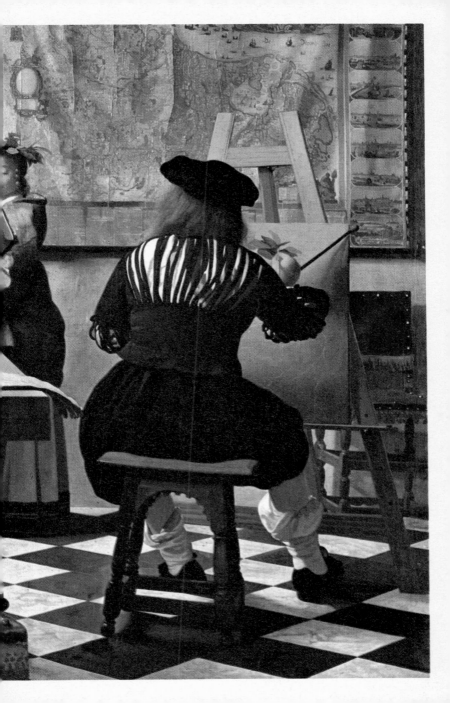

21 Lady with her Maidservant
Oil on canvas/92 × 78.7
New York, Frick Collection

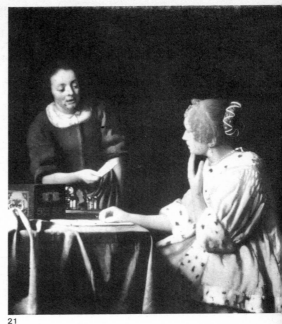

21

22 The Love Letter
Oil on canvas/44 × 38.5/s.
Amsterdam, Rijkmuseum

**(opposite) The Art of Painting
(No. 19; detail)**
*The map in the background,
which depicts the Netherlands,
alludes to the fame and
importance of Netherlandish
painting. It is significant that
the map does not show
political boundaries as they
were in Vermeer's lifetime, but
as they were before 1581,
when the entire Netherlands
were part of the Burgundian
empire.*

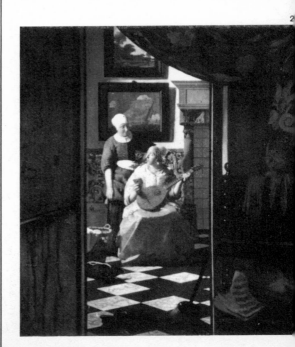

23 The Astronomer
Oil on canvas/50 × 45/s.d.
1668
Paris, Private collection
Both signature and date are
of doubtful authenticity

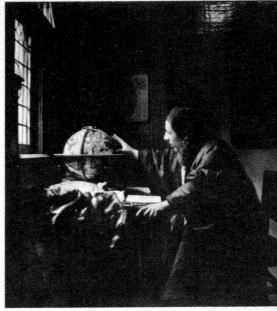

23

24 The Geographer
Oil on canvas/53 × 46.5/
s.d. 1669
Frankfurt, Staedelsches
Kunstinstitut
Both signature and date are
of doubtful authenticity

Lady writing a Letter (No. 20)
*The painting glimpsed in the
background is probably the
Bas met dootshoofd (bass
with skull) which is
mentioned in Vermeer's
widow's inventory. Vermeer
was an art dealer as well as a
painter and occasionally
introduced paintings that he
owned into the background
of his own pictures.*

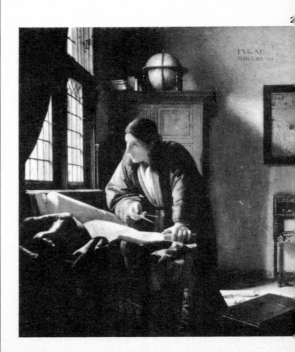

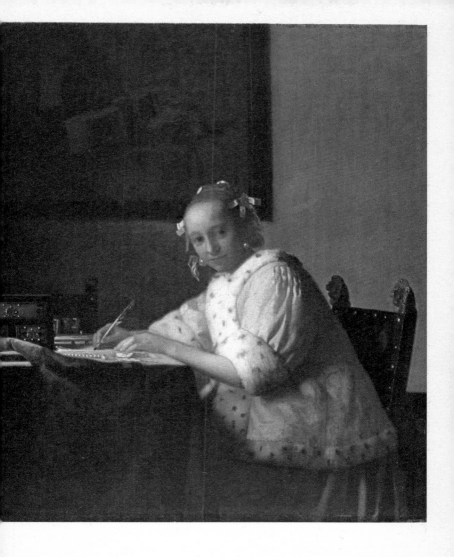

(over page) **Lady with her Maidservant (No. 21; detail)**
The large format of this painting strikes an unusual note in Vermeer's oeuvre. It is his only attempt to give a humble household theme truly monumental force. The result must not have satisfied him. We may deduce from the flat undifferentiated areas, especially in the main figure, that he left the painting unfinished.

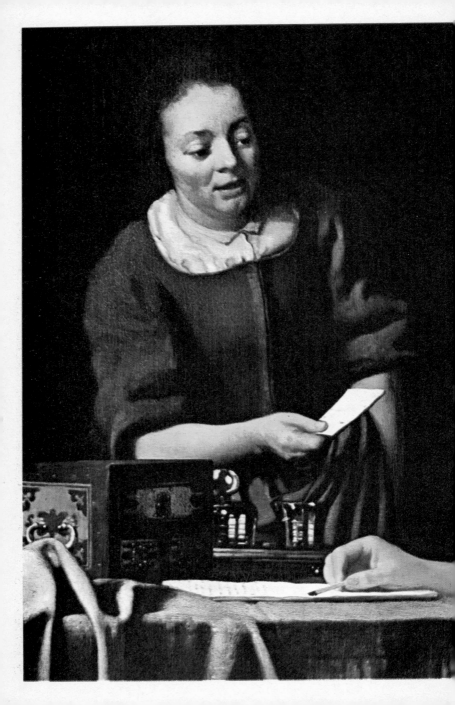

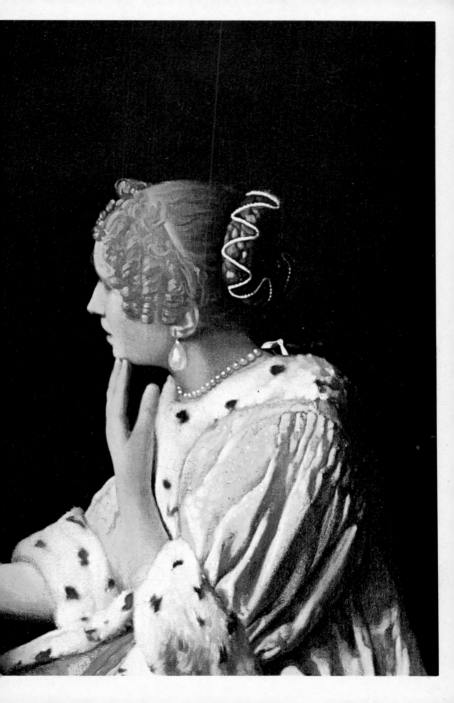

25 Lady standing at a Virginal
Oil on canvas/51.7 × 45.2/s.
London, National Gallery
Datable around 1670 on
grounds of costume

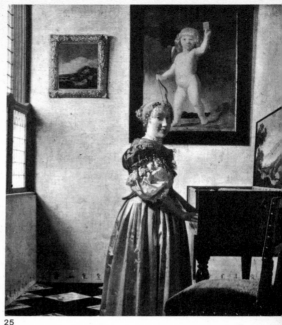

25

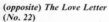

26

26 The Lacemaker
Oil on panel/24 × 21/s.
Paris, Louvre

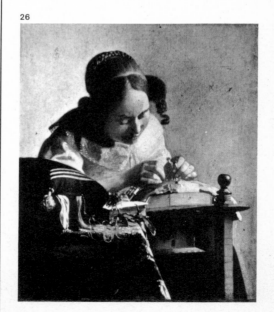

**(opposite) The Love Letter
(No. 22)**
*In a brightly-lit background a
lady interrupts her music to
receive a letter from her maid.
Vermeer's contemporaries
would have deduced, from the
seascape on the wall behind,
that this was a love letter. In
contemporary emblem books
ships at sea are compared to
lovers' hearts.*

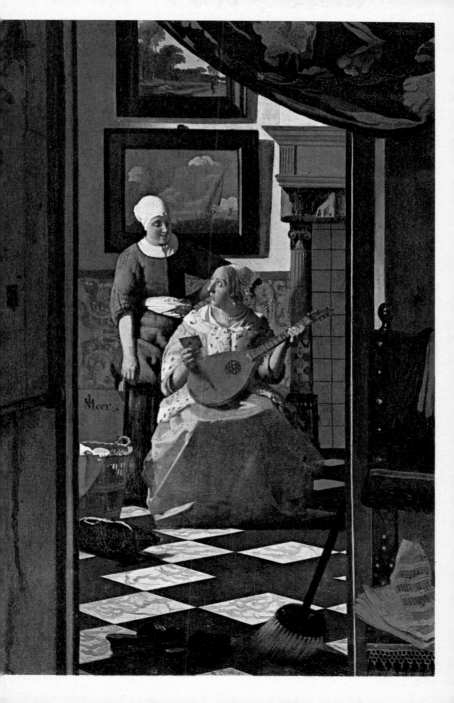

27 Lady writing a Letter with her Maid
Oil on canvas/71 × 59/s.
Blessington (Ireland) Beit
Collection

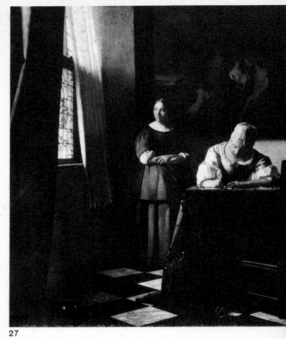

27

(opposite) The Love Letter
(No. 22; detail)
The lute which the lady sets
aside is significant as a symbol
of love, for music-making
symbolized the harmony
between lovers. Sometimes the
lover is compared with a
musical instrument, whose
strings or keys are touched by
the loved one.

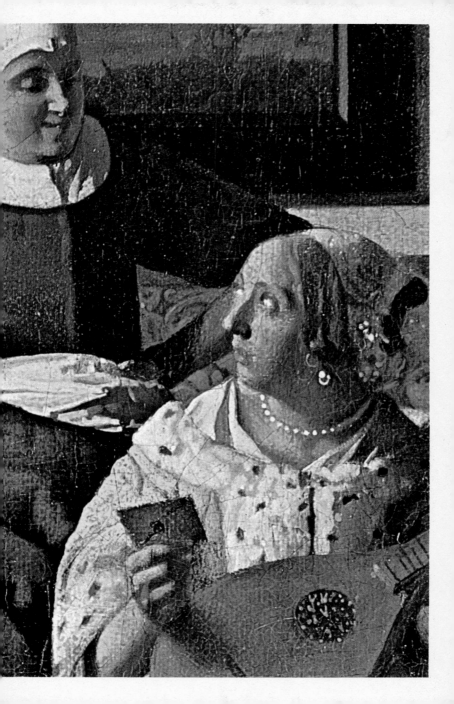

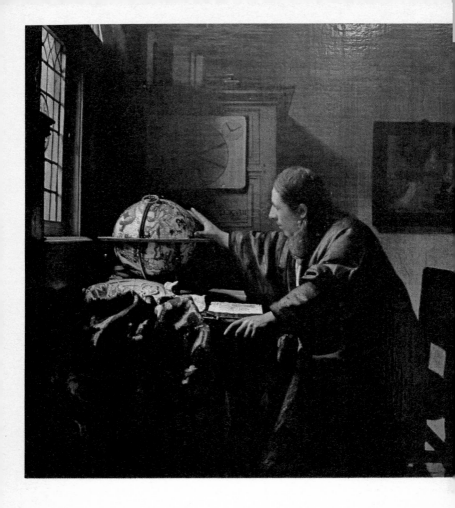

The Astronomer (No. 23)
*When a very accurate print
was made of this painting in
1792, the date of 1668 (in
Roman numerals below
Vermeer's monogram) was
absent. It is likely, therefore,
that it was added
subsequently. It was probably
based on an original
inscription or annotation by
Vermeer, for the painting fits
into the sequence of his work
at around this date.*

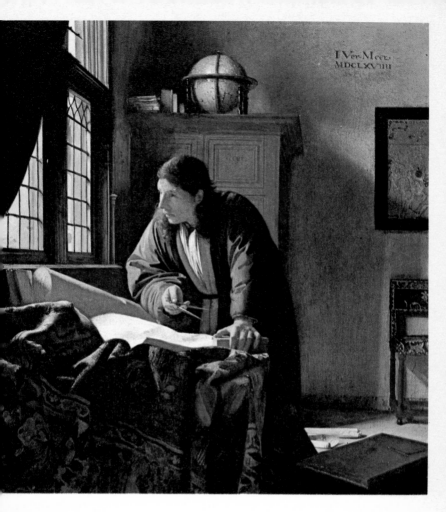

e Geographer (No. 24)
e terrestrial globe on the
nboard can be identified with
e second edition, dated 1618,
a globe made by the
ondius family. Vermeer uses
e same globe in The
legory of Faith *(No. 29).*

28 The Guitar Player
Oil on canvas/53 × 46.3/s.
Kenwood (London), Iveagh
Bequest
An old copy exists (No. 28a,
Philadelphia, J. G. Johnson
Collection), differing only in
the player's hairstyle, which
seems to date from a little
before 1700; the copyist
probably paid careful
attention to current fashion
and brought it up to date

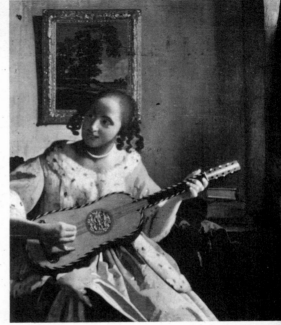

28

28a

*(opposite) The Astronomer
(No. 23; detail)*
*This celestial globe has been
identified with a globe, of
which three copies are
preserved, produced by the
Hondius family of
cartographers. It was sold as a
pair with the terrestrial globe
shown in Vermeer's* The
Geographer. *This may
indicate that the two paintings
were intended as companion
pieces.*

76

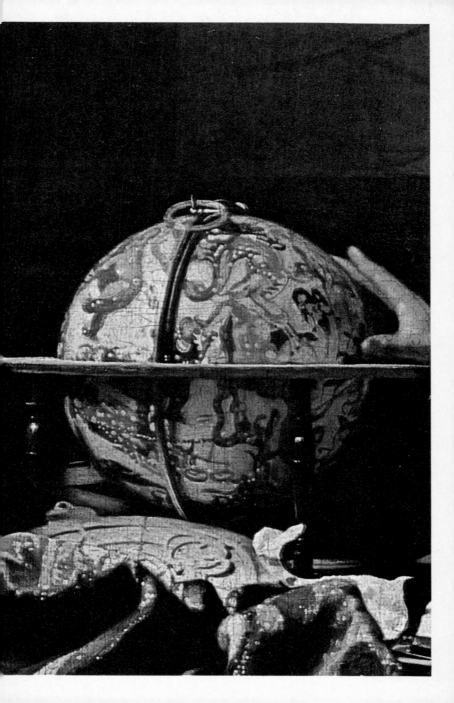

29 The Allegory of Faith
Oil on canvas/113 × 88
New York, Metropolitan
Museum of Art

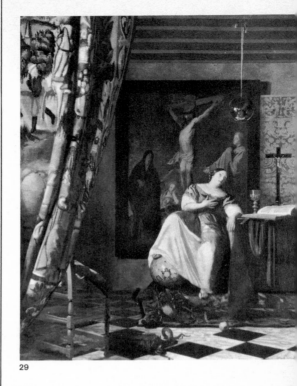

29

30

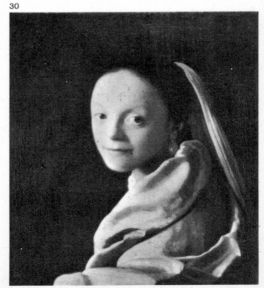

30 Head of a Girl
Oil on canvas/45 × 40/s.
New York, Metropolitan
Museum of Art

**(opposite) Lady Standing at a
Virginal (No. 25; detail)**
*The painting hanging on the
wall has been attributed to
Cesar van Everdingen and may
well be the* Cupid *which is
listed in the inventory of
Vermeer's widow. In this
context the Cupid with his
one playing card probably
stands for fidelity to one rather
than the love of many.*

78

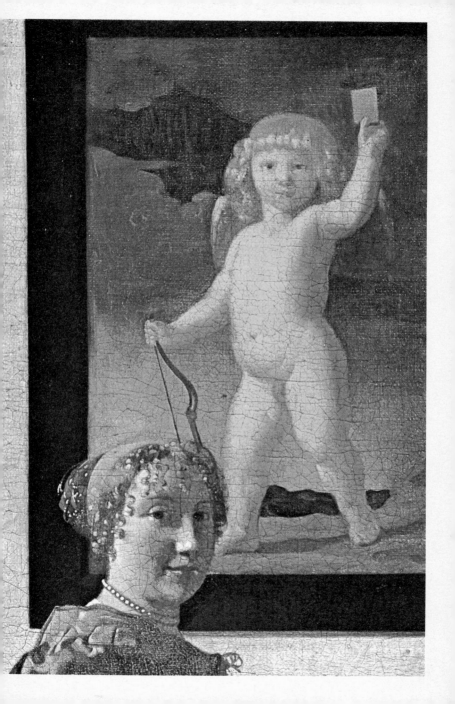

31 Lady seated at a Virginal
Oil on canvas/51.5 × 45.5/s.
London, National Gallery

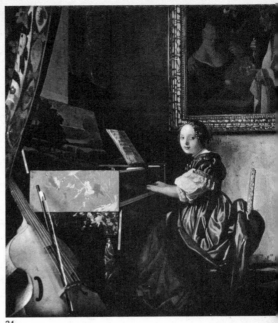

31

**(opposite) The Lacemaker
(No. 26; detail)**
*The cushion on the left is a
naaikussen (sewing-cushion)
and the red and white strings
are bundles of thread hanging
from it. Cushions of this type
were made of hard material
covered with velvet or cloth
and were opened by lifting the
upper half. Inside were wooden
compartments in which rolls of
thread could be stored.*

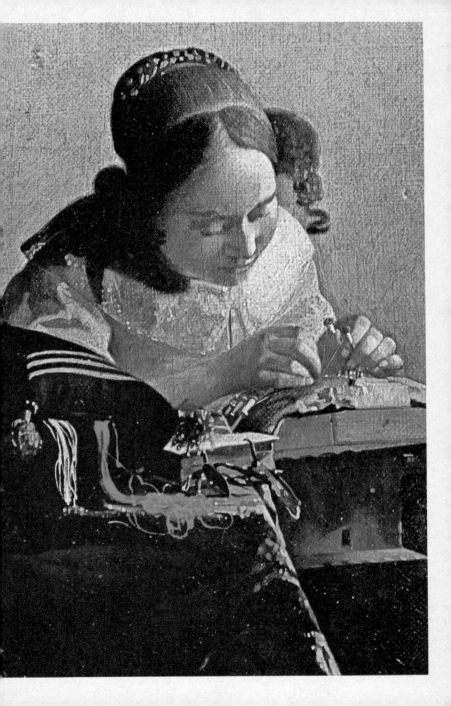

32 The Lute-player
Oil on canvas/52 × 46
New York, Metropolitan
Museum of Art
Some well-preserved details
make it clear that this
painting was by Vermeer.
However, most of the
painting is in such bad
condition that it can be
regarded only as a document

33 Gentleman and Girl with Music
Oil on canvas/38.7 × 43.9
New York, Frick Collection
In such poor condition that it
is impossible to establish
whether this is a damaged
authentic painting or a copy

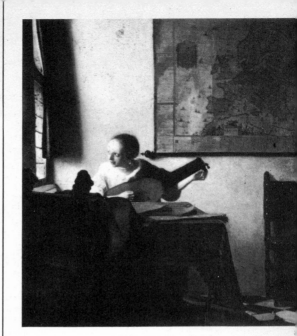

(opposite) Lady writing a Letter with her Maid (No. 27; detail)
In an arrangement that now looks familiar to us (used previously in Lady writing a Letter *and* Lady with her Maidservant*), Vermeer depicts two figures near a table, in a room lit from the left through a window. Here, Vermeer combines his characteristic serenity with a solemnity and grandeur which are lacking in the earlier works.*

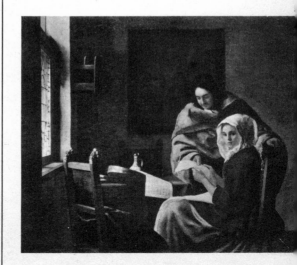

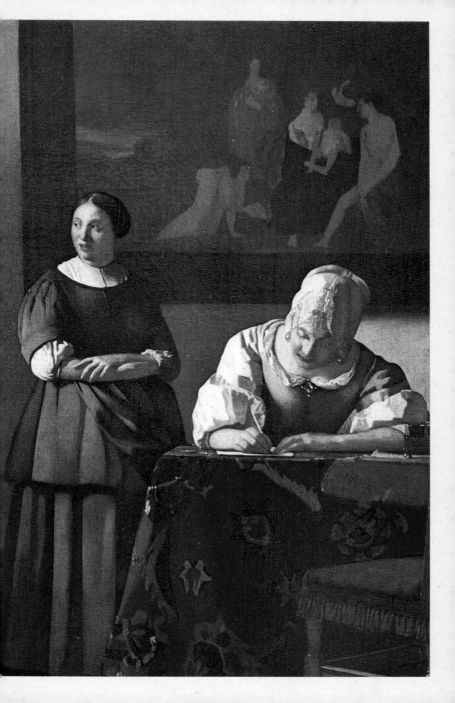

34 Girl with a Red Hat
Oil on panel/23 × 18/s.
Washington, National
Gallery of Art
The X-ray photograph (No.
34a) shows this was painted
over the top of an upturned
male portrait by another
artist

34

34a

35

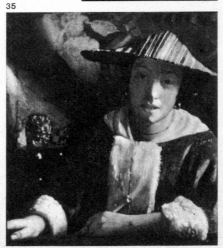

35 Girl with a Flute
Oil on panel/20.2 × 18
Washington, National
Gallery of Art

**(opposite) The Guitar Player
(No. 28; detail)**
*The composition of this
painting is unique in Vermeer's
work. The figure is placed so
far to the left that her right
arm is cut off by the edge of
the picture, while the right
side of the picture remains
dramatically empty. The result
is strangely unbalanced.*

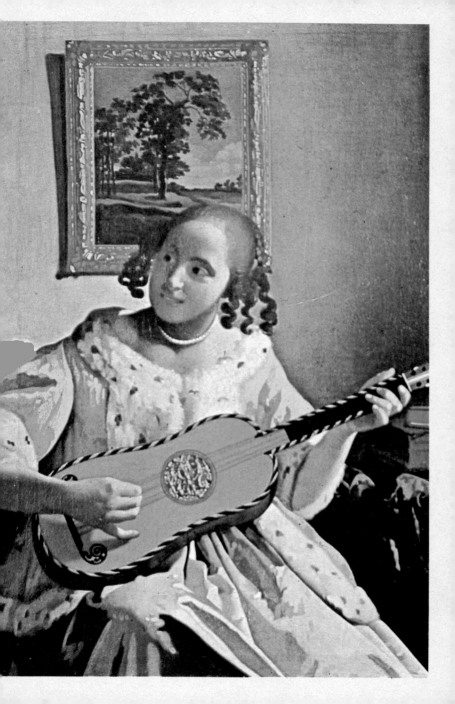

36 Girl seated at the Spinet
Oil on canvas/24.5 × 19.5
Private collection

37 Portrait of an Artist
Oil on canvas/60 × 51.5
Miami (Florida), The Bass
Museum of Art
There exists an analogous
engraving by Joannes
Meyssens (1612–70), a painter
and engraver active in
Antwerp and Brussels, of
which a single copy is known
(No. 37a, Paris, Bibliothèque
Nationale). The Miami
painting, although
corresponding with the
engraving, is not considered
acceptable as autograph: the
hairstyle of the subject and
the style of the coat were not
in fashion before 1670–8; the
composition, colours and
design are not in keeping with
Vermeer's work during the
final years

**(opposite) The Allegory of
Faith (No. 29; detail)**
*The programme for this
allegory is taken from Cesare
Ripa's* Iconologia, *which
appeared in a Dutch edition in
1644. The painting of* The
Crucifixion *is by Jacob
Jordaens.*

**Lost works, auctioned 16 May
1696 in Amsterdam**

38 View of Houses in Delft
Of the two examples listed in
the catalogue only one (No.
9) is preserved

39 Portrait in Antique Dress
Of the three paintings listed
on the same theme, only two
have survived (Nos. 18 and
30)

**Gentleman washing his Hands,
with a glimpse into an
adjoining room, and a figure**
Sold for 95 florins, listed no.
34 in the auction catalogue

**41 Lady and Gentleman in a
Room**
Sold for 18 florins, listed no.
10 in the auction calogue

36

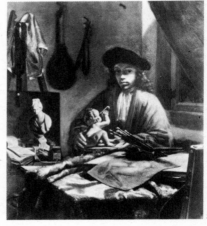

37

37a

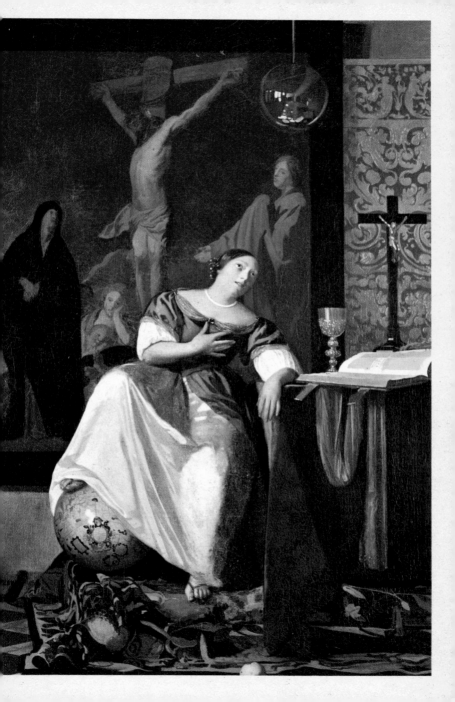

Van Meegeren

by Maurizio Villa

The problem of false attributions or even of actual fakes has affected almost all the great masters and is commonplace in the history of art. In the case of Vermeer, however, this question has assumed unusual proportions, attracting the interest of the press as much as of the art historian. The events connected with the so-called van Meegeren case did not in the end add much to the knowledge of Vermeer's oeuvre, but they did undoubtedly throw a revealing light on the prevailing conception of art and of the artist in general.

The facts, involved as they may be, are by now well known. In 1937 art historians welcomed the discovery of an unknown painting by Vermeer, *Meeting at Emmaus* (plate A), the authenticity of which had been confirmed by Abraham Bredius, the authoritative and well-known expert on the Dutch painter, as well as amply proved by chemical analysis and by radioscopic and microspectroscopic exam-

(opposite) The Allegory of Faith (No. 29; detail)
The glass sphere hanging from the ceiling and the crucifix on the table were probably derived from a print representing Faith in the Jesuit Willem Hesius' book Emblemata Sacra de Fide, Spe, Charitate, *published in 1636.*

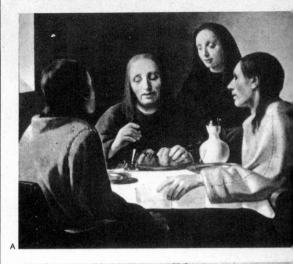

A

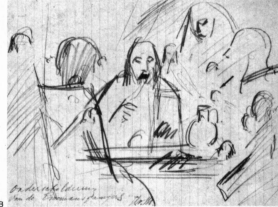

B

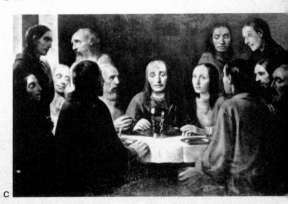

C

inations. The painting, acquired for Dfl.550,000 by the Rembrandt Vereeniging, had been donated to the Boymans Museum of Rotterdam; here, it had been put on show amongst the masterpieces, and critics from all over the world had almost unanimously declared it one of the most significant paintings by Vermeer.

During the years which followed, new paintings by Vermeer kept being discovered. At the end of 1939 there were already a *Benediction of Jacob* (plate E), a *Portrait of Christ*, a *Last Supper* (plate C) and a *Christ and the Adulterous Woman* (plate D). In 1943, in the middle of World War II, the Rijksmuseum of Amsterdam bought a *Christ washing the Apostles Feet* for Dfl.1,250,000. Such an unusual number of discoveries aroused some suspicions, but the certainty of the attributions and the particular conditions of Holland, occupied by the Germans, prevented any detailed investigation of the origins of the paintings. Only in 1945, immediately after the war, a not unknown Dutch painter, Han Anthonius van Meegeren,

(opposite) *The Allegory of Faith* (No. 29; detail)
This painting, unusual in Vermeer's oeuvre, was most probably a commissioned work. That Vermeer felt uneasy in painting it is suggested by the numerous elements that he took from his earlier Art of Painting, *such as the tapestry hanging on the left, the ceiling, the floor and the general disposition of space.*

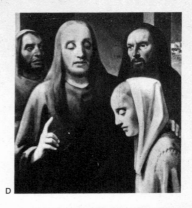

D

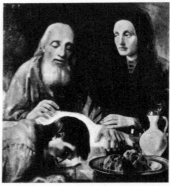

E

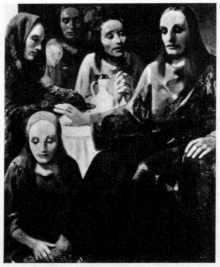

F

who had been sent to prison as a collaborator for having sold to the Nazi minister Goering the recently discovered painting *Christ and the Adulterous Woman*, declared that he had painted it himself, just as he had painted all the other works recently attributed to Vermeer, including the *Meeting at Emmaus*. His confession sparked off a long and involved trial. The Dutch magistrates wanted certain proof of his contentions and asked him to paint, while in prison, a painting good enough to be attributed to the seventeenth-century master. Having been provided with all he needed, in a few months van Meegeren painted a *Jesus and the Doctors* (plate I) which, even in its unfinished state, definitively proved the truth of his assertions. Sentenced to be detained for a year, the faker died in prison at the end of 1947. In his studio two more unfinished Vermeers were found: a *Music Player* and *Woman Reading* (plates G and H).

The technique van Meegeren used for his fakes was undoubtedly sophisticated and right to the end some regarded him as a mythomaniac. In order to paint the *Meeting at Emmaus* he had bought a

(opposite) Head of a Girl (No. 30; detail)
A variant of an earlier painting, the Girl with a Pearl Earring *(No. 18), this is painted in the schematic style of Vermeer's late period, about 1672–4. Compare, for example, the different treatment of the cloth in the two pictures.*

92

G
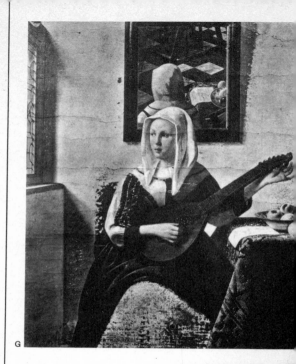

H
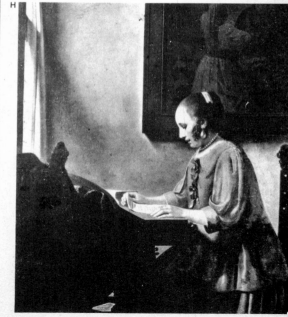

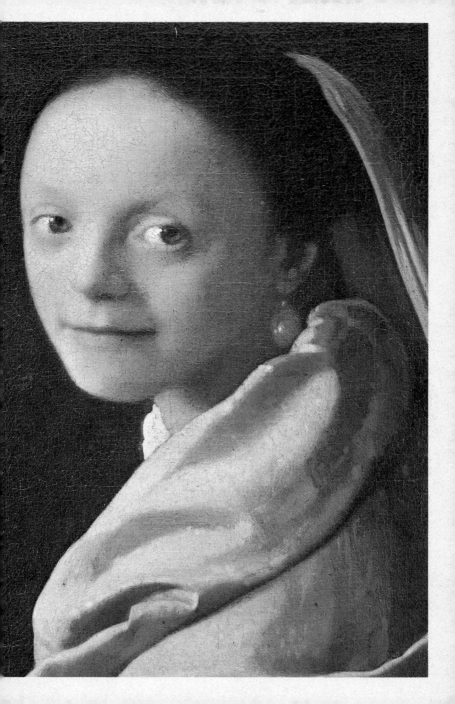

mediocre seventeenth-century canvas depicting the *Resurrection of Lazarus*, and had used every bit of it, including the nails and the leather listels, so as to reproduce perfectly a period piece. His brushes were made with the hairs of polecat from a shaving brush; the composition of his colours was as close as possible to that of three centuries before, even though later and more accurate analysis did show traces of substances unknown in the seventeenth century; and the disposition of the figures was planned in such a way as to avoid interfering with the blank spaces of the original (plate B shows the preparatory sketch by van Meegeren).

In van Meegeren's confession there was an element of boasting thus providing some foundations for the doubts about its truthfulness; so much so that the debate sparked off by the affair was not diminished either by his conviction or by his death.

(opposite) **Lady seated at a Virginal** (*No. 31; detail*)
A product of Vermeer's last, difficult years, the painting shows a noticeable decline in his skill. A few elements – the viola da gamba, and the marbelized virginal – are executed with the strength and virtuosity demonstrated in The Lady Standing at the Virginal, *but the folds of the costume are now harsh and coarsely executed, and the blots making up the frame of the painting on the back wall lack the sureness of touch apparent in the frame of the small landscape in the earlier picture. This painting must have been made shortly before Vermeer's death.*

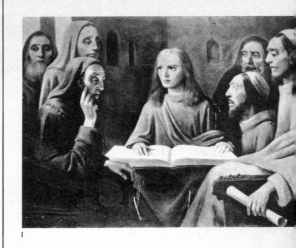

I

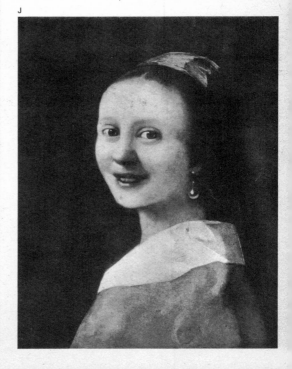

J

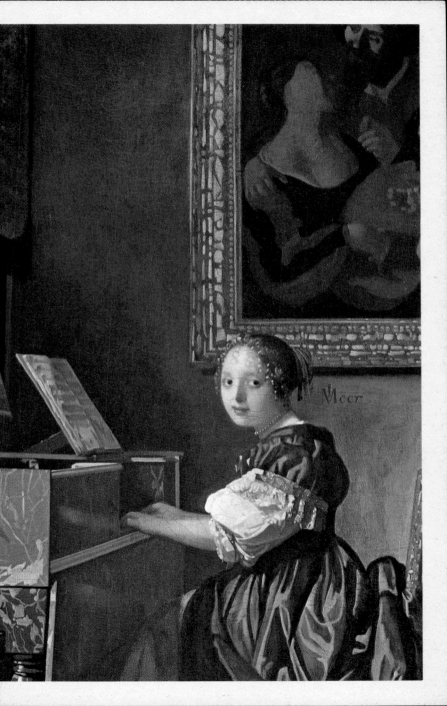

More investigations followed, during which a Dutch collector supported, against the opinions of the experts, the authenticity of the Vermeers in question. Finally, in 1958, Coremans was able to show the photograph of a *Hunting Scene* attributed to Hondius, the canvas of which had been used by van Meegeren to paint his fake *Last Supper*. This and other irrefutable proof definitively showed that van Meegeren had not simply been boasting.

What had prompted van Meegeren to devote himself for years to painting fakes of Vermeer? Obviously one reason was the desire to get rich since, at the time of his arrest, his estate was found to be large. But above all, as he himself admitted, he wanted to be revenged on the critics who had never acknowledged his ability. It is however more interesting to ask oneself how a faker, however capable, could deceive so many experts for so long. The answer is not so easy. It has been asserted that suspicions should have been aroused by the rigidity of van Meegeren's paintings, often very different from Vermeer's softness of design and tonality. However, art history is not an exact science and even the most rigorous research can often be affected by interests, feelings and cultural attitudes. The relatively small number of known works by Vermeer and little documentation of his life, accompanied by the exceptional greatness of his art, meant that the work of someone with willpower and talent was difficult to check; van Meegeren quite simply exploited circumstances which were favourable for his aims. And the whole story does not lack a certain irony, since van Meegeren, by painting – as it has been ascertained – his fakes in the style of his own paintings, finally achieved his revenge on the critics, who appreciated in the faker those very qualities they had previously denied in the painter.

Van Meegeren was not the only artist to produce fake Vermeers. Following the scandal of the *Meeting at Emmaus*, many other paintings which had been accepted as 'discoveries' had to be recognized as fakes. Even the *Smiling Girl* of the National Gallery, Washington (plate J), regarded in 1926 as a signed Vermeer, has since 1948 been rejected by all the experts. The National Gallery, however, continued to show it as a Vermeer until 1973, when it was finally deposited in the archives.

Select Bibliography

W. Bürger (E. J. Th. Thoré): 'Van der Meer of Delft', in *Gazette des Beaux-Arts*, vol. 21, 1866 pp. 297–330, 458–70 and 542–75

P. T. A. Swillens: *Johannes Vermeer, painter of Delft, 1632–75*, Utrecht, Brussels 1950

L. Gowing: *Vermeer*. London 1952 (2nd ed. 1971)

P. Bianconi: *L'opera completa di Vermeer*, Milan 1967 (with introduction by G. Ungaretti and complete bibliography)

A. Blankert: *Vermeer of Delft. Complete edition of the paintings*, Oxford 1978 (with essays by R. Ruurs and W. L. van de Watering, complete bibliography, documented sources, and origin of the works)

J. M. Montias: 'New Documents on Vermeer and his Family', in *Oud Holland 91*, 1977, p. 267–87

Photocredits
Bildarchiv Preussicher Kulturbesitz, Berlin: p. 48.
National Gallery of Art, Washington: p. 67.
All other colour and black and white pictures are from the Rizzoli Photoarchive. The publishers would like to acknowledge help in the preparation of this volume from Christopher Brown, Deputy Keeper, National Gallery, London.

First published in Great Britain by
Granada Publishing 1981
Frogmore, St Albans, Herts AL2 2NF

Copyright © Rizzoli Editore 1979

ISBN (hardback) 0 246 11295 6
ISBN (paperback) 0 586 05139 2

Printed in Italy

Granada ®
Granada Publishing ®